S0-BMW-135

VILLAGE LIBRARY

IMAGES
*of America*

# OSTERVILLE
# VILLAGE LIBRARY

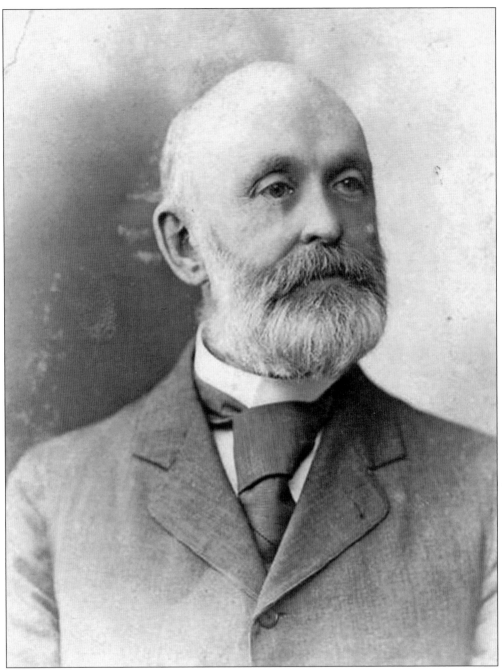

William Lloyd Garrison Jr. (1838–1909), the founder of the Osterville Free Library, deeded the property in 1881 on Main Street for the new library, which was officially incorporated and opened the following year. A summer resident of Wianno, Garrison raised funds through a village-wide subscription and oversaw the beginnings of the library. (Osterville Village Library.)

ON THE COVER: Cutting the 75th anniversary cake of the Osterville Free Library in 1957 are, from left to right, Robert Sims, Beatrice Crosby, librarian Eva Weber, Louise Hallowell, and Joel Davis. (Osterville Village Library.)

IMAGES
*of America*

# OSTERVILLE
# VILLAGE LIBRARY

Anthony M. Sammarco
for the Osterville Village Library

ARCADIA
PUBLISHING

Copyright © 2017 by Anthony M. Sammarco for the Osterville Village Library
ISBN 978-1-4671-2540-6

Published by Arcadia Publishing
Charleston, South Carolina

Printed in the United States of America

Library of Congress Control Number: 2016953803

For all general information, please contact Arcadia Publishing:
Telephone 843-853-2070
Fax 843-853-0044
E-mail sales@arcadiapublishing.com
For customer service and orders:
Toll-Free 1-888-313-2665

Visit us on the Internet at www.arcadiapublishing.com

*This book is dedicated to the patrons of Osterville
Village Library—past, present, and future.*

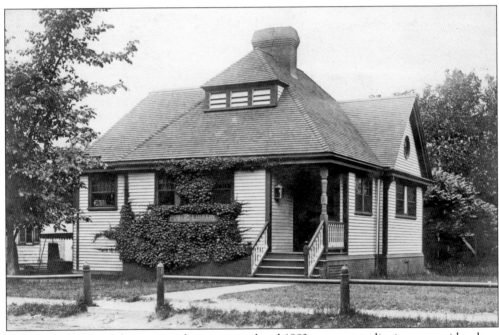

The Osterville Free Library, according to an undated 1882 newspaper clipping, was said to be a "picturesque building and [with] furnishings of the 'Queen Anne' style that are neat, substantial and beautiful" and would serve Osterville as the library from 1882 until 1958. Today, the former library is a part of the Oyster Island Emporium. (Author's collection.)

# CONTENTS

# Acknowledgments

I would like to thank the following for their assistance in the researching and writing of this book: the trustees of the Osterville Village Library—Laurie Young, president; Karen Bailey; Irene Haney; Richard J. Sullivan; Sean G. Doherty; Richard Colman; Mark E. Cote; Talida Flonta; Sara H. Hunter; Barclay Kass; Claudia Mahoney; Ellen Merlesena; Diane Pemberton; Susan White; the staff of the Osterville Village Library—Cyndy Cotton, executive director; Maryann Colombo; John LeRoy; Jan Ham; Billy Tringali; Tiffany Turner; Ginny Angelo; Ione Callan; Melissa Cavill; Michael Crocker; Nancy Stevenson; Cathy Molle; Ethan Pulsifer; Cheryl Rowland; Phyllis Whitney; Scott Hoder; Louise Fullam; Lisa Nagel; Lisa Hall Conway; and Elaine Horne.

I would also like to thank the following for a variety of kindnesses: Patricia Avallone; Susan T. Belekewicz, former executive director of the Osterville Library, for suggesting this book; Rev. Heather Bailes Baker, Osterville Methodist Church; Boston University School of Theology Library, Kara Jackman; Robert Bownes; Adrienne Alger Buffum; Dan Campia; Gloria Smith-Carney; Eileen Condon Cashin; Hutchinson and Pasqualina Cedmarco; Cesidio Cedrone; Paul Chesbro, Osterville town historian; Colortek, Jackie Anderson and Jimmy Kwong; Carol Crosby; Malcolm Crosby; Lucy Cundiff; Caitrin Cunningham, my patient title manager, who went above and beyond the call of duty; Martha Curley; Jay Donahue; Shirley Eastman; Mary Anne English; Tom Evans; Marylou Fair, Barnstable Historical Commission; Ford 3 Architects, LLC, Jeremiah Ford; David Garrison; Ann Colgan Gillis; Ann Gould; Jim Gould; Sara Hunter; Mary J. Kakas; Jane Hoffman Kenney; James Leonard; Philip Leonard; Megan Mahoney; Darren Malone; Moira McClintock; Gail Nemetz; Gail Campana Nightingale; Orleans Camera; Osterville Garden Club, Penny Linett, president; Barnes and Ba Riznik; Judith Staples; Virginia Campana Stimets; Erin L. Vosgien, Arcadia acquisitions editor; Jenna Weathers; Jennifer Morgan Williams, Osterville Historical Museum; Cathryn A. Wright; Sarah Wyatt; and Diane Zaglia.

Unless otherwise credited, all photographs are from the archives of the Osterville Village Library.

# INTRODUCTION

The mission of the Osterville Village Library is to inspire lifelong learning, advance knowledge, and strengthen our community. To fulfill our mission, we rely on library staff, collections, programs, and the participation of our patrons and community.

Noah Webster (1758–1843), a lexicographer and the reformer of our spelling foibles, is often referred to as the "Father of American Scholarship and Education." *Webster's* dictionary describes a library as "a place where books, magazines, and other materials such as videos and musical recordings are available for people to use or borrow" or "a room in a person's house where books are kept." Simple enough, but the Osterville Village Library (from 1882 to 2012, the Osterville Free Library) is really so much more than this simple description. Established in 1873 as the Osterville Literary Society, the library was first located in the converted dining room of the James Allan Lovell House, and the fledgling lending library had Thankful Hamblin Ames serving as the first librarian. Within a few years, the bookshelves outgrew the room, and it was moved to the Dry Swamp Academy located behind the Osterville Baptist Church on Main Street; this new library room was overseen by the Reverend Edward Bourne Hinckley, who served as the second librarian.

William Lloyd Garrison Jr., son of the great 19th-century abolitionist and publisher of the *Liberator* from 1831 to 1865, took an active interest in the library. A summer resident of Wianno, he drew up a list of names of friends and neighbors from whom he sought subscriptions and pledges to build a new library. The incorporators of this new library were William Lloyd Garrison Jr., Anna Davis Hallowell, Herman W. Chaplin, Francis J. Garrison, Pierrepont Wise, Charles W. Storey, and Jeremiah Chaplin. As stated in its articles of incorporation, the library served to provide, "the maintenance of a free library and reading room at Osterville in the Town of Barnstable in this Commonwealth, and the promotion of study and reading." On December 30, 1881, a dedication ceremony was held in the Methodist Episcopal church directly opposite the new library at Mulberry Corners, where many assembled local residents sang the hymn "America" and then listened to Garrison give what an old newspaper clipping describes as a "modest, tender and kind but witty address . . . [of] the history of the library from his first thought of it until the design was finished. He clearly set forth its purpose and usefulness, gave a financial statement, and commended the institution to the use and care of the people." Officially opened to the public on January 2, 1882, the new Osterville Free Library was the fourth library to be established on Cape Cod, being preceded by the Sturgis Library of 1863, the Hyannis Library of 1865, and the Centerville Library of 1869.

Over the next 75 years, much of it overseen by librarians Rev. Edward Hinckley, Eliza Lovell, Bertha Lovell Hallett, and Katherine Hinckley, the small Queen Anne–style library continued to grow and offer a lending library of books; a place for both students and adults to study and read newspapers, journals, and magazines; and a space to act as a community center. The residents of Osterville, both permanent and summer, joined together to support the library and its annual fair and contribute to its support. In 1907, it was said that the library's "needs have been modest, the yearly expenses averaging a little over $500. Its use has been constant and increasing and its value to the village ample appreciated." However, by 1932, the library "kept pace with the growth of the community, as the telephone, the motor, the radio, have drawn it into more intimate contact with the world outside of Cape Cod." By 1957, the small library had provided yeoman's duty and was stretched to the limit. It was said that increased requests "for certain books and cramped quarters for stacking and storing same have made it necessary . . . to plan a campaign to have a larger and more adequate facilities to keep abreast of present times."

A capital campaign was started with an anonymous donor matching funds raised up to $100,000 before September 1, 1958. So successful was this 75th anniversary campaign that the library trustees engaged local architect Stanley F. Alger Jr. of Alger & Gunn, who designed an attractive Colonial Revival library as a refashioning of the old Eaton Store Block at the corner of Wianno Avenue and West Bay Road. A redbrick one-story library with a columned entrance and a large bow window on the right side was designed with ample space for an adults' lounge, separate study areas for adults and young adults, and a children's reading area with a hall that could be used for both lectures and storytelling hours. The library, prominently sited on a corner, anchored the village with the elementary school within walking distance as well as the stores along Wianno Avenue.

With the establishment of the Friends of the Osterville Free Library, which continues to this day, residents and friends have joined together as a group to make others aware of the library and its importance in the life of the community. With expanded services to both adults and young adults, including children's programming, the library's circulation dramatically increased, as did events and programs that brought in a larger and far more diverse audience than ever before. From benefit concerts, fundraisers, and art exhibits to Kurt Vonnegut, who led the biweekly book discussions in the 1970s "Great Books Committee," to award-winning children's film project *Friction Fiction* by Marjorie Lenk in 1972, to kite flying day at Dowses Beach, the golf tournament at the Wianno Golf Course, fashion shows, and the annual car raffle, each event has expanded the traditional aspects of what a library offers to the village, all the while creating a sense of enjoyment and inclusion for all residents.

Today, the Osterville Village Library is located in a modern state-of-the-art facility that was designed by Charles Bellingrath and Ford3 Architects, and its grand opening in 2012 brought hundreds of residents and friends who shared, with pride, in the vast achievements since 1882, when the library was formally incorporated and dedicated to the ideals of a free lending library and in "the promotion of study and reading."

As said in its dedication through words written by Rev. Edward Bourne Hinckley: "We dedicate with heart and voice / This building of our love and choice / And may its influence reach afar / As streams of light from Evening's Star."

More information can be found at www.ostervillevillagelibrary.org.

# One

# MULBERRY CORNERS

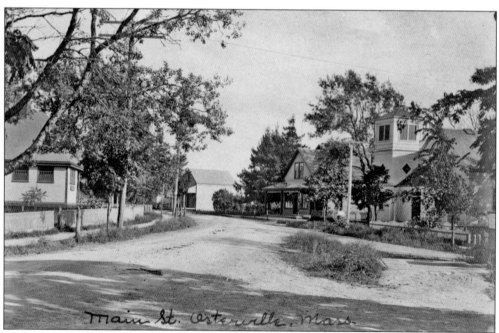

*Main St. Osterville, Mass.*

Mulberry Corners is the junction of Main and Bay Streets, Parker Road, and Pine Lane Extension and has long been the center of Osterville Village. Shown here in 1905, the Methodist Episcopal church is on the right, beside the grocery store of Horace Scudder Parker. The Osterville Free Library can be seen on the left. For many years, the library was the center of village affairs, serving educational, social, and civic purposes. (Author's collection.)

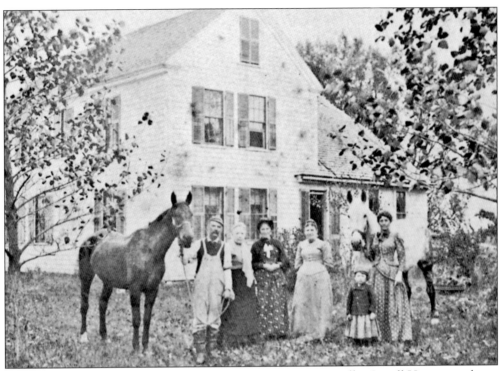

The James Allen Lovell House was the first location of the lending library of the Osterville Free Library. Thankful Ames, who lived in the house, kept the library in the former dining room, and residents were encouraged to stop by on Saturdays to borrow books and periodicals that had been donated or acquired for the fledgling library from members of the Chaplin and Hallett families. The house still stands, though moved from West Bay Road across from the library to 34 Lovell Road in Osterville. Members of the Lovell family pose with their horses in front of the house. (Paul Chesbro.)

Thankful Hamblin Ames (1846–1934) was the first librarian of the Osterville Free Library. Established in 1873 as the Osterville Literary Society, the library was first located in the converted dining room of the Lovell House, where Thankful and Granville Ames lived. After the death of her husband in 1886, she managed the Cotocheset House, a popular summer guesthouse on Seaview Avenue in Wianno, overlooking Vineyard Sound. (Paul Chesbro.)

The Reverend Edward Bourne Hinckley (1826–1903) was the second librarian of the Osterville Free Library, serving from 1882 to 1885 at an annual salary of $200. A native of Osterville and son of Oliver and Louisa Crocker Hinckley, he had served as a Methodist Episcopal minister in towns throughout the Providence Conference and was a veteran of the Civil War. A well-respected resident, he "bore himself with that modest dignity and sweet urbanity which is so becoming in an ambassador of Jesus Christ." (Boston University School of Theology Library.)

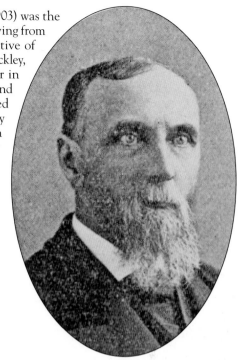

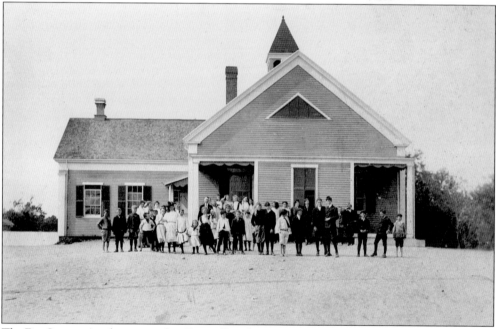

The Dry Swamp Academy served as Osterville's elementary school, which had been opened in 1857 behind the Baptist church on Main Street. Named because of the swampland that surrounded it, the academy was the second location of the Osterville Free Library—in a formerly vacant room until 1882. The academy served as the village school until the construction of the Bay School in 1915. The academy building then became the Osterville Community Center, which was destroyed by fire in 1981. (Osterville Historical Museum.)

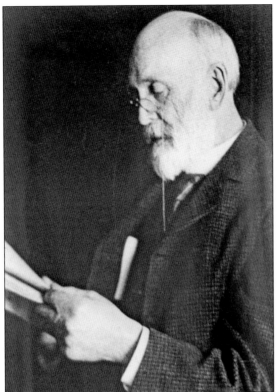

William Lloyd Garrison Jr. (1838–1909) was the founder of the Osterville Free Library. He donated the $3,000 necessary to build the Queen Anne–style structure that served residents of Wianno and Osterville. Garrison led a successful village-wide subscription drive to support the idea of establishing a library. In September 1881, Lucy A. Lovell conveyed to Garrison the land on Main Street on which the new library was to be built.

This ink drawing of the Osterville Free Library was done by Walter James Fenn (1862–1961) and appears in an article on "Cape Cod" in the September 1883 *Century Magazine*. According to minutes of a library trustees' meeting, the library was erected by Charles Daniel Sr., a prominent local builder in Barnstable who had built Wayside, the Garrison summerhouse, "largely by the generosity of Mr. W.L. Garrison of Boston . . . aided by others who have summer cottages" in Osterville.

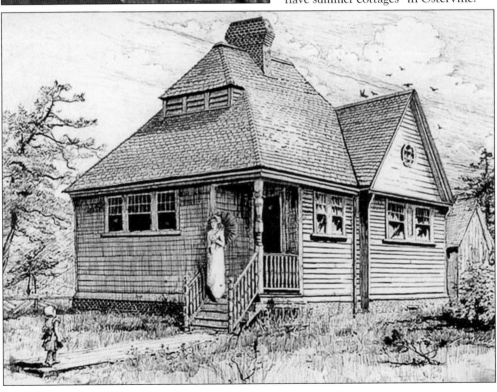

Charles Daniel Sr. (1838–1913) was a native of Aberdeen, Scotland, and settled in Osterville in 1881. The noted local builder constructed the four-room Osterville Free Library in 1881. His sons Charles Daniel Jr. and Robert M. Daniel continued the family building concern into the 20th century as Daniel Brothers Inc. (Paul Chesbro.)

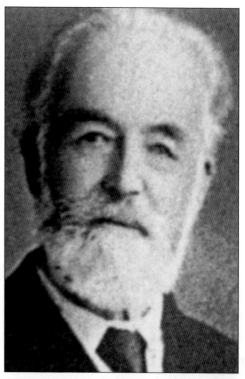

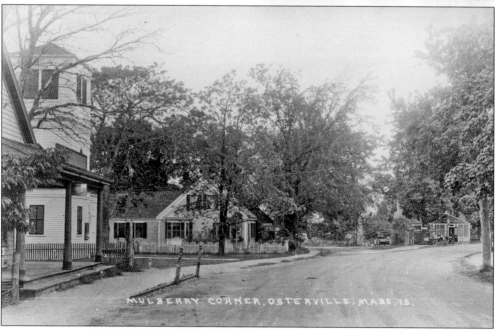

The charm of Mulberry Corners in Osterville is evident in this turn-of-the-century photograph. Mature trees at the intersection of Parker Road and Main and Bay Streets add to its bucolic quality, as do the mulberry trees that gave the corner its name. On the left are the Methodist Episcopal church and the Salmon Frank and Eudora Jones Braley House at the corner of Parker Road. On the far right is the Mulberry Corners Ice Cream Emporium.

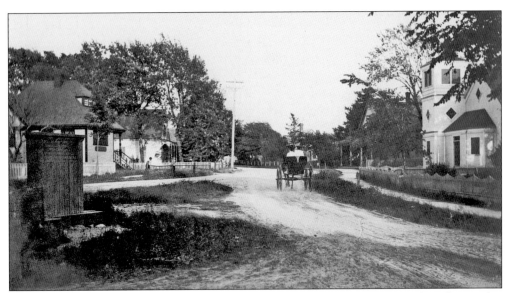

The bucolic quality of Mulberry Corners in Osterville Village was never more evident than in this early-20th-century photograph of two women in a horse-drawn carriage passing the library (left) and the Methodist Episcopal church (right), which has since been remodeled and its tower removed and is today the site of Checkerberry House Interiors. On the far left are the old hay scales, once an important aspect of the agrarian way of village life. (Osterville Historical Museum.)

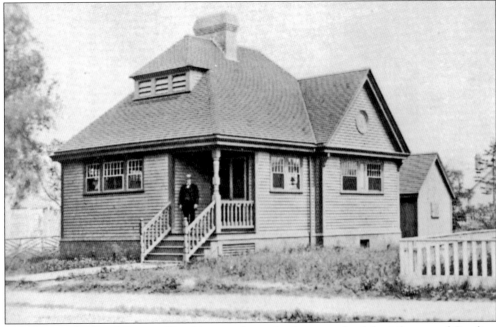

The Reverend Edward Bourne Hinckley stands on the front porch of the Library and Reading Room in 1882, the year he became librarian as well as the year his wife, Ruth Smith Hinckley, died. The library was neat, commodious, and somewhat compact. And it was said by the library trustees that "the comfort and good taste of the building has attracted favorable notice beyond the limits of the town, and it is hoped that summer visitors . . . will interest themselves in its welfare by adding new volumes to its shelves and helping us to free it from debt." (Paul Chesbro.)

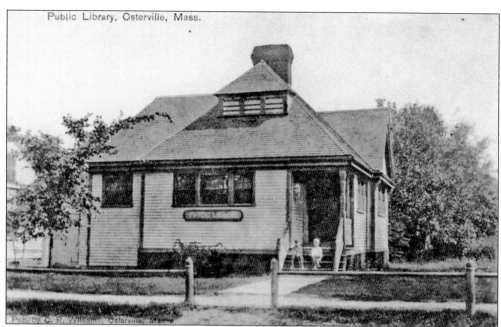

Pub. by C. R. William, Osterville, Mass.

Sitting on the steps of the Osterville Free Library about 1910, obviously before it was open for patrons, are Walter Scudder (right) and an unidentified friend. The "Public Library" plaque on the facade under the tri-banked windows hangs in the present library, and the old library is now part of the Oyster Island Emporium. (Osterville Historical Museum.)

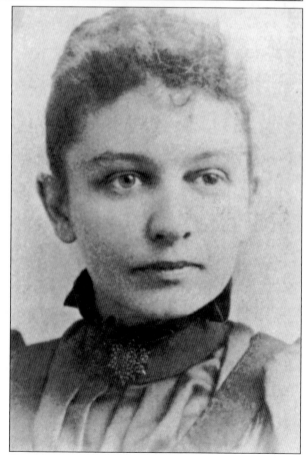

Bertha Lovell Hallett (1861–1941) served as the fourth librarian of the Osterville Free Library, succeeding her mother, Eliza Lovell. Bertha graduated in 1879 from the Framingham Normal School and was a teacher at the Dry Swamp Academy in Osterville. Her husband was Samuel Worthington Hallett, a graduate of Amherst College, who served as superintendant of schools in Barnstable from 1891 to 1896.

15

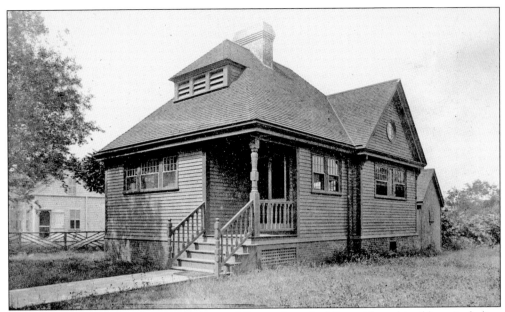

The Osterville Free Library was a well-designed Queen Anne building with multi-gables—including a louvered facade dormer, banks of eight-over-one windows, and a side entrance with a small porch featuring turned column and balustrade railings–that was declared "neat, substantial, and beautiful" at its dedication in 1882. A concrete walk replaced the wooden planks in 1905. (Osterville Historical Museum.)

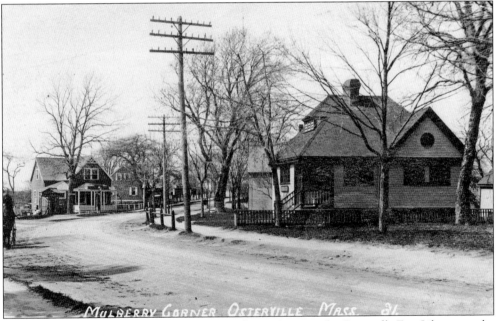

In this view looking west on Main Street at Mulberry Corners, the Osterville Free Library can be seen on the right, and the Crosby Dry Goods Store (later the Osterville Fruit Store), situated at the corner of Bay Street and Parker Road, is center left. In the 1920s, Main Street was widened and paved and the buildings on the south side of the street were moved back to allow for the village expansion. (Osterville Historical Museum.)

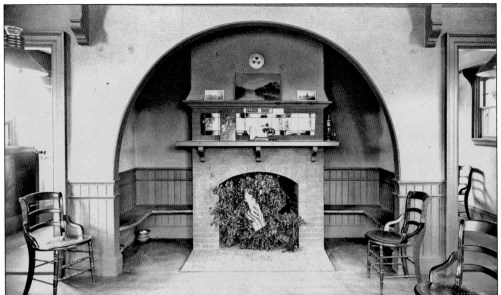

The Osterville Free Library had a hooded fireplace with a wood mantelpiece set within an archway and an inglenook of wooden seats on either side. Seen in December 1881, with evergreen boughs in the fireplace, it is bedecked for the holiday season but would not be officially opened to the public until January 2, 1882. (Osterville Historical Museum.)

Katherine Hinckley (1877–1961), fondly known in Osterville as "Miss Kathy," served as librarian for a remarkable 39 years. The daughter of George and Sophronia Gerst Hinckley and the granddaughter of Rev. Edward Bourne Hinckley, she is seen in her youth in a photograph taken in Manhattan. She was dedicated to her job as librarian and was feted by the library patrons upon her retirement in 1956 at the age of 79. (Osterville Historical Museum.)

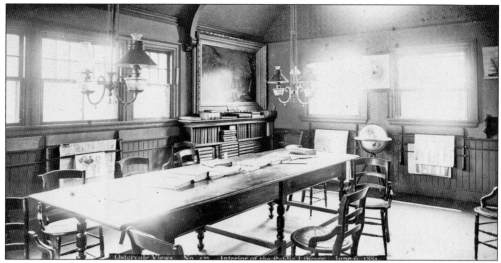

The reading room of the library, seen in 1884, had large eight-over-one mullioned windows for ample light as well as two shaded oil lamp chandeliers for overcast days and dark nights. Notice the wall-mounted newspaper racks and the globe in front of the windows on the right and the huge landscape painting above the half bookcase. In 1883, it was commented that "the people of Osterville are proud of their Library building, and its contents, and well they may be." (Osterville Historical Museum.)

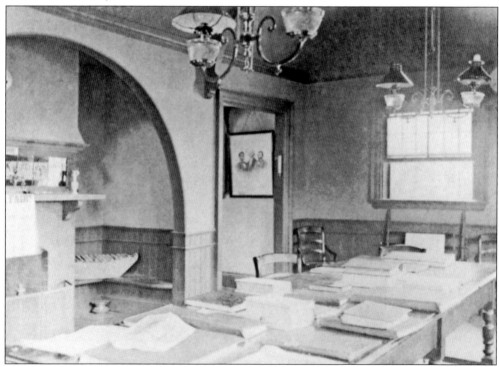

The reading room of the library a century ago had a reading table covered with books and periodicals that might interest library patrons. The room was illuminated by oil lamp chandeliers for the first 35 years, and the fireplace seen on the left was used to heat the rooms. Note the large framed print in the hallway of presidents Abraham Lincoln, George Washington, and Ulysses S. Grant.

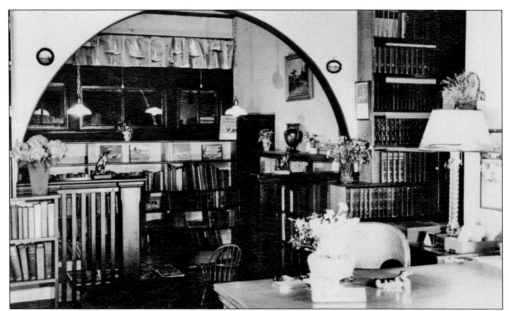

The interior of the library was a combination of a Queen Anne cottage and a library with nooks and crannies that seemed to have full and half bookshelves at every turn. Shown here, the archway led to the Children's Room, and Miss Kathy's desk can be seen in the foreground. Enlarged in 1906 with an addition and a new furnace, the library was also newly painted that year. Today, the archway can still be seen in the Oyster Island Emporium, which has been remodeled from the structure's original use as a library. (Osterville Historical Museum.)

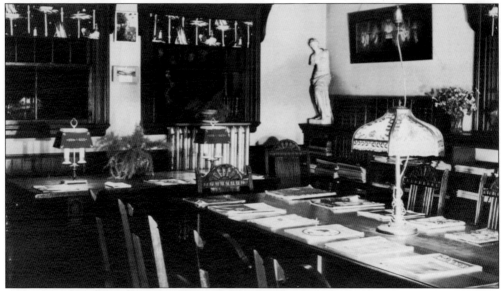

The reading room had an electric slag glass lamp in the center of an oak library table with two boulliotte lamps featuring adjustable oval black-finished metal shades in front of the windows for added reading light; the library was first wired for electricity in 1917. The carved wooden side chairs are still used in the trustees meeting room a century later. A plaster statue of Aphrodite, more commonly known as the Venus de Milo, can be seen in the corner. Notice the nautical-themed window cornices. (Osterville Historical Museum.)

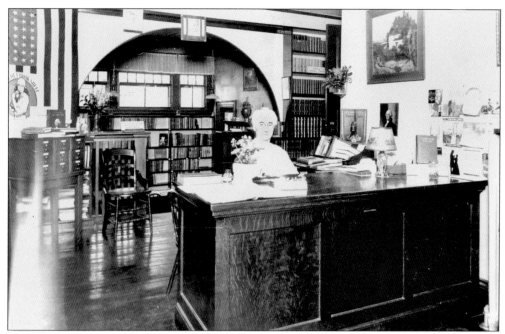

Katherine Hinckley, librarian for an incredible 39 years, sits at her oak desk at the old Osterville Free Library. During the summer months, Miss Kathy would bring books to Dowses Beach, trying to encourage those enjoying a day at the beach to read. Notice the multi-drawer card catalog on the left, used to research a subject before the advent of Google, as well as the "Girl Scout Book Shelf" above it. (Osterville Historical Museum.)

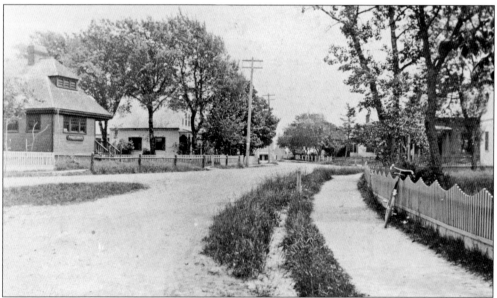

The library, visible at left, was to be a prominent landmark in Mulberry Corners in Osterville for 75 years. By 1957, a new library was planned for Osterville Village by the remodeling of the old Eaton Store at Wianno Avenue and West Bay Road. The former library was sold in 1958 to Robert P. and Norma Sims, who incorporated it into their store the Osterville House and Garden Shop. Today, the former library is a part of the Oyster Island Emporium.

# Two

# MOVING ON TO WIANNO AVENUE

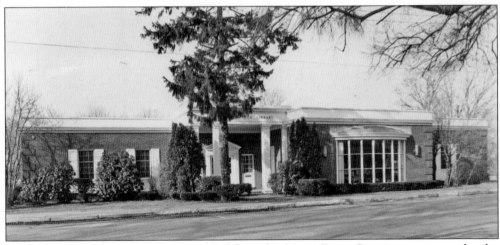

The Osterville Free Library was remodeled from the former Eaton Store, a one-story red cedar building, at the corner of Wianno Avenue and West Bay Road. Local Osterville architect Stanley F. Alger created an impressive redbrick Colonial Revival exterior with a columned entrance and a massive bowed picture window to the right. Fred Sobbart was the contractor. The library was dedicated on July 27, 1958.

Stanley F. Alger was a partner of Owen Russell Gunn in the architectural firm Alger & Gunn, a prominent architectural firm in Osterville, later Hyannis. As architect of the Osterville Free Library, Alger literally transformed the building and "handsome red brick replaced the redwood cedar." The painting on right was painted and donated to the library by Dr. Fritz B. Talbot. (Adrienne Alger Buffam.)

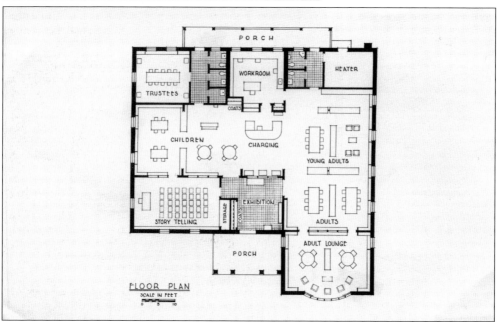

The interior of the remodeled and enlarged Eaton Store had many different sections for the use of adults, young adults, and children, with a lecture hall and storytelling room, adult lounge, trustees' room, and a workroom, all of which were quickly used by residents. A newspaper clipping on the dedication notes that "the overall effect [of the library interior] is one of cool spaciousness as the décor blends from one room to another."

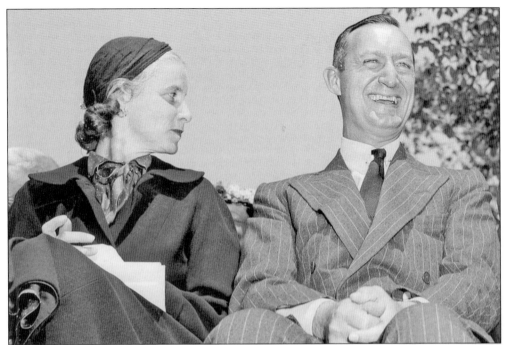

Rachel Lowe Lambert Lloyd Mellon (also known as "Bunny") and Paul Mellon were summer residents of Osterville's Oyster Harbors, and their then anonymous gift of $100,000 for the new library was required to be matched by residents and summer residents with contributions made prior to September 1, 1958, which allowed for the new library renovations. The immensely successful library campaign eventually exceeded the required match by $2,000, and the Mellons gave an additional $100,000.

The bookplate of the Osterville Free Library prominently displayed a woodcut-style image of the Crosby Catboat first built in 1850 by brothers Horace S. and C. Worthington Crosby based on the design of their late father, Andrew Crosby. Today, the library's cupola is surmounted by a copper weather vane representing a gaff-rigged Crosby sloop.

The Trustees of the Osterville Free Library

cordially invite you to a reception

to be held at the Library

on Wednesday, the eighteenth of July

from three until five o'clock

to honor our Librarian Emeritus

Miss Katherine E. Hinckley

1917 — 1956

The invitation to an afternoon reception to honor Katherine E. Hinckley was an important aspect of the library, as she had served as librarian for almost four decades and was admired and respected by everyone in Osterville. Who else, honestly, would walk to Dowses Beach with a supply of library books to encourage beachgoers to read while they basked in sun and surf?

Katherine E. Hinckley, fondly known as "Miss Kathy," served as librarian for 39 years before her retirement in 1956. Her obituary notes that "Miss Hinckley is an example of the unheralded but vitally necessary public servants who made life that more interesting and enjoyable." Stalwart, dedicated, and incredibly adept at overseeing the library collection, she ably managed the small library with skill and patience—especially with young boys who seemed to enjoy innocent pranks.

Terry Ann Rogers signs the guest book at the dedication and public opening of the newly remodeled library on Sunday, July 27, 1958. With over 400 people in attendance, it seemed as if the entire Osterville community came together that afternoon to share in the pride of not just accomplishing a successful fundraiser but also the remodeling of a former store into an attractive community library.

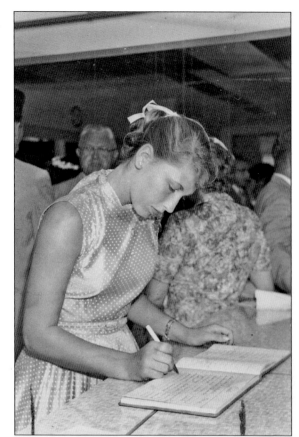

At the library dedication, just before the ceremony began, there was a short discussion on the outline of the event. From left to right are Joel P. Davis, Robert P. Sims, librarian Eva Watson Weber, and Richard C. Macallister, president of the library. Fr. Walter J. Buckley gave the invocation, and Rev. A. Alan Travers the benediction.

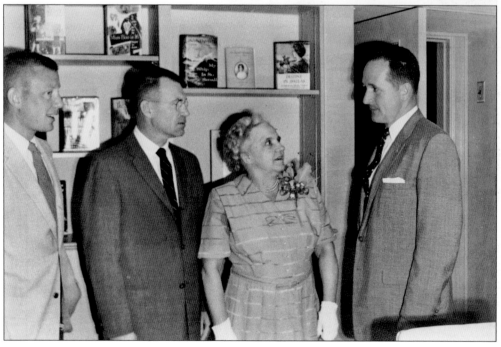

Richard C. Macallister served as president of the Osterville Free Library in 1958 when the library was moved from Main Street to Wianno Avenue. A resident of Osterville, he started his own life insurance business in the village. Macallister served as president of the Osterville Rotary Club, the Osterville Library, and the Administrative Board of Osterville Methodist Church and was a trustee of Cape Cod Hospital.

Edith Stephenson Garrison was the daughter-in-law of the founder of the Osterville Free Library. At the dedication, she spoke of her family's long interest in the library. The family of William Lloyd Garrison Jr. had long summered in Wianno since just after the Civil War, and they maintained a continued and abiding interest in the welfare and continued success of the library.

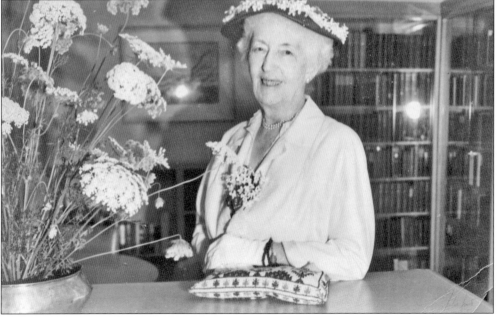

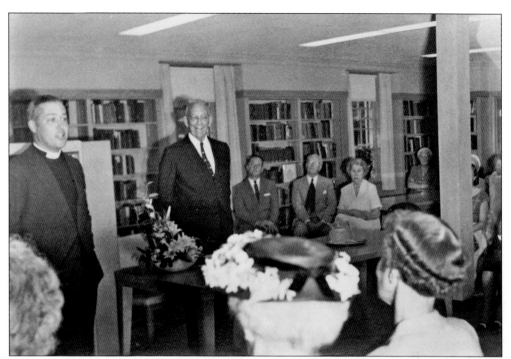

At the dedication of the new library, Rev. James R. MacColl III (left) of St. Peter's Church in Osterville spoke briefly about the new library with Dr. Fritz Bradley Talbot (center). Seated in the distance are, from left to right, Richard Macallister, C. Roscoe Hinckley, and Carrie Hinckley.

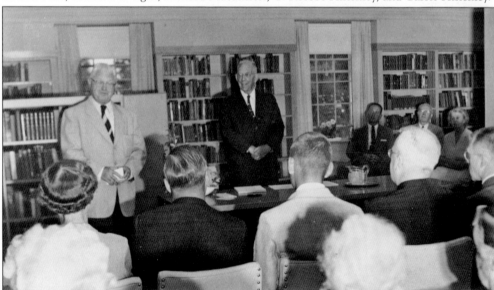

Dr. Fritz Bradley Talbot (center) spoke at the dedication of the new library. A prominent clinical professor of pediatrics at Harvard Medical School, he was the founding chief in 1910 of the Children's Medical Service at the Massachusetts General Hospital in Boston. With his medical team, he developed the term "allergy," and his research of children's responses to food and skin tests became the worldwide standard and the basis of the allergy-immunology specialty. He served as a dedicated trustee of the library for many years.

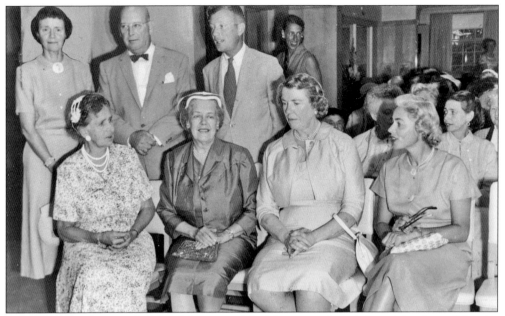

Some of those who attended the dedication of the library are, from left to right, (seated) Louise Harding Hallowell, Dorothy Dowse Putnam, Lucia Bebee Rockwood, and Carolyn Crossett Rowland; (standing) Anne Pillow Halliday, Walcott Ames, and Joel P. Davis.

Louise T. Harding Hallowell was a dedicated library trustee for many years, as was her mother-in-law, Anna Davis Hallowell, who was one of the original incorporators of the Osterville Free Library in 1882. Between these two women, the Hallowell family was involved with the library as trustees for over eight decades.

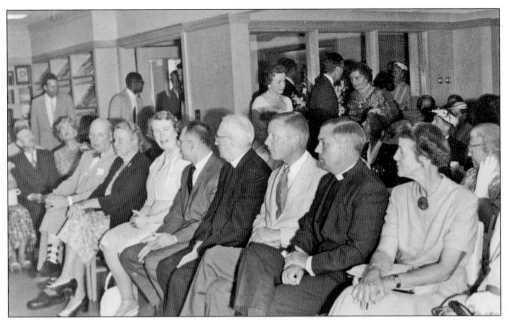

It was a standing room only crowd at the dedication of the Osterville Free Library. Here, in the first row, are library trustees and honored guests who were to speak at the dedication. Seated from left to right are Wolcott Ames, Margery Bird, Lucia Rockwood, Robert Sims, Fr. Walter J. Buckley, Joel Davis, Rev. James McColl, and Anne Pillow Halliday.

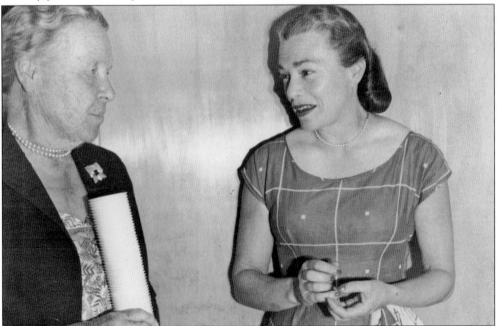

Sharing a conversation at the reception following the library dedication are Margery Phelps Bird, who was replenishing the Dixie cups at the punch bowl to help hostesses Norma Williams Sims and Catherine Hoffman Macallister; and Betty Kilborne, who wrote and directed many of the musicals performed in the 1950s and 1960s, including *Miss Liberty's Liberty*, at the Wianno Club to benefit the library.

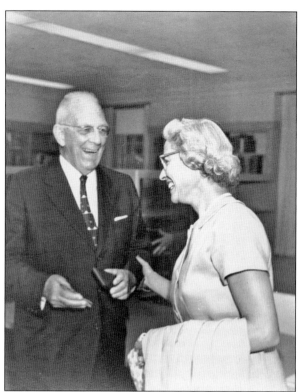

Dr. Fritz Bradley Talbot and Carolyn Crossett Rowland enjoy an obviously amusing story at the library opening. Rowland's father was Edward C. Crossett, who had left a generous bequest in his will for the library, and his daughter was to continue her family's generosity. A fireside reading room in the new library was dedicated in her honor in 2012.

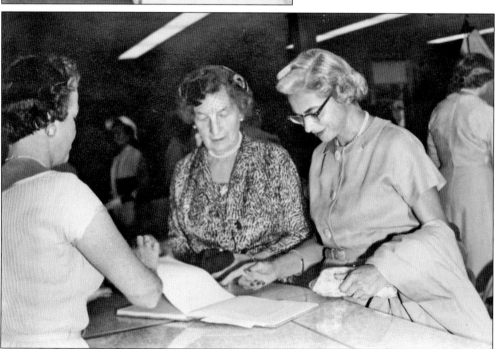

Signing the guest book at the library dedication are, from left to right, Mary Linehan, Beatrice Bill Talbot, and Carolyn Crossett Rowland. Linehan had charge of the guest register and encouraged all in attendance to record their names.

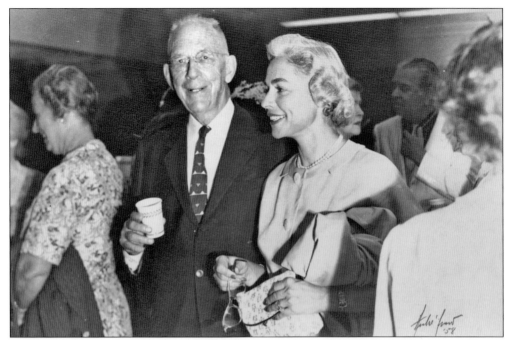

Dr. Fritz Bradley Talbot and Carolyn Crossett Rowland served as trustees of the Osterville Free Library. Though summer residents, they lived in Brookline and Boston's Back Bay, respectively, and maintained a great interest in the welfare and well-being of the library.

For the holidays in 1958, the columns at the entrance to the Osterville Free Library were decorated with laurel roping. The grounds had been landscaped by Sields Brothers, and the library has always been a warm and welcoming presence in Osterville Village. It is not just a place to borrow books or peruse newspapers and magazines, but is also *the* destination in Osterville Village.

The Osterville Garden Club

———.

The dedication of the sundial in memory of

Dorothy Ethridge Gould

will take place on the grounds of the Osterville Free Library

Monday, July 27, 1959

3:30 p. m.

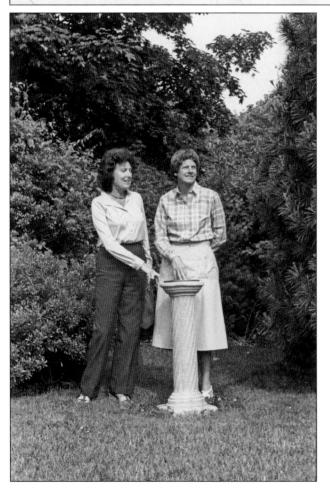

The Osterville Garden Club, longtime and stalwart supporters of the Osterville Free Library, dedicated a sundial in memory of club member Dorothy Ethridge Gould in 1959. The garden club had been founded in 1949 and federated in 1951; it is a member of the National Garden Clubs of America.

Standing at the Gould Memorial Sundial are Nancy Alger (left) and Ruth Hiebert Davis. Since its founding in 1949, the Osterville Garden Club has made a commitment to beautify the villages of Barnstable. This lovely sundial was an early gesture of the club's club commitment to enhance local gardens, and since 1953, the club has donated flower arrangements to beautify the library.

# *Three*

# A LIBRARY SERVING OSTERVILLE VILLAGE

The Osterville Free Library, remodeled by Alger and Gunn and occupied in 1958, was to see further expansion a decade later through the generosity of the Maxwell W. Upson Foundation, which made an unrestricted donation of $100,000 that was used to expand and make renovations to the library in 1968. The Birtwistle House, which stood just north of the library, was bought in 1968 and demolished for the North Room addition and a library green.

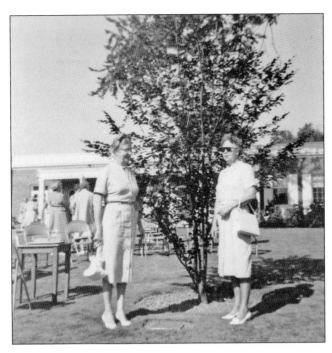

Jessie Boult Leonard (right) and Charlotte Boult Tallman attended the 1962 dedication of a copper beech tree planted on the library grounds in memory of Katherine Hinckley, the former librarian and their maternal aunt. The tree was bought from Seapuit Nursery, owned by Joel Davis, and planted by Philip Leonard, with a large group of friends and library patrons in attendance who fondly remembered Miss Kathy. (Judy Staples.)

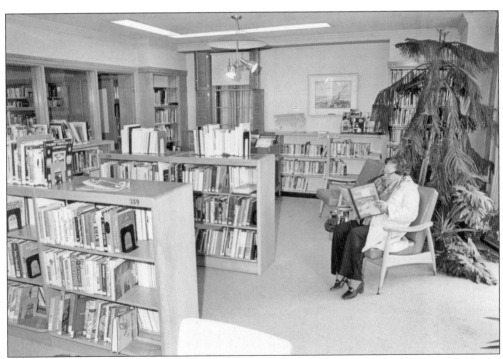

Sitting in a comfortable armchair, a library patron reads in the pleasant reading room with the bow window. With shelves filled with interesting books and plants and flowers scattered around and ample reading light, the library was always a pleasant way to spend an hour or so perusing the books and periodicals. A library survey in 1977 indicated that the "composite patron is 54½, female, resident, uses the Osterville Free Library in the afternoon on a weekly basis."

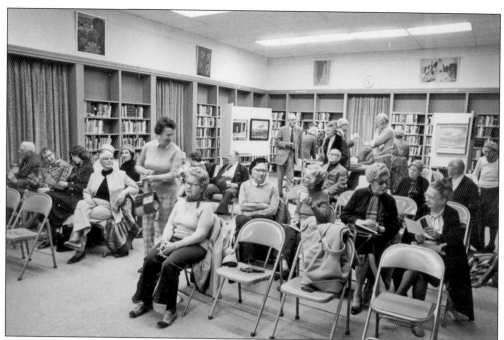

A group of Ostervillians gathers for the weekly Friday morning movie program in the North Room. Full-length feature films were shown throughout the year and were a welcome activity after the theater on Main Street in Osterville Village was closed. Charles Schmonsees was the official projectionist, and he said of his many years of volunteering on movie day that he enjoyed it "besides insuring that I see all the movies."

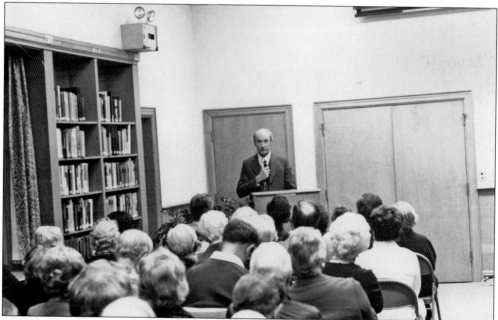

Paul Chesbro, Osterville's town historian, presents a lecture on the history of Osterville Village to a large audience in the North Room. Chesbro's books on Osterville include the two-volume set *Osterville: A History of the Village* and *Osterville: A Walk Through the Past.*

In 1984, the library offered a dynamic new program to allow timid library patrons to "Join the Computer Age." Shown here, library patrons are having their first digital lesson on the newfangled thing called a computer.

Kenneth Kinkor presented a fascinating program at the library on the ship *Whydah*. Kinkor was the compiler and editor of the *Whydah Sourcebook*, which contains a vast collection of 17th- and 18th-century archival records concerning the history of the British slave ship *Whydah*, its capture by the crew of the pirate Samuel Bellamy, and its demise at Cape Cod, with the court trial and testimonies of the surviving crew. Today, the Whydah Pirate Museum is in West Yarmouth on Cape Cod.

After the library had been expanded to include the North Room, thanks to the Maxwell Upson Foundation, the friends of the library asked Bob Vila of the immensely popular PBS show *This Old House* to speak at the library. Here, Jean Crompton Ellis dons a plastic hard hat to get into construction mode as she introduces Vila, who spoke on his popular television show and its many restoration projects.

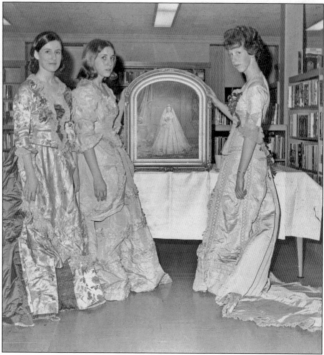

Surrounding a 19th-century portrait of Mrs. F. Hallett Lovell in her wedding gown are, from left to right, Kathy Harbert, Valerie Cloud, and Janet Williams. This was a cosponsored event with the Osterville Historical Society billed as an "informal old fashioned evening" at the library, with the girls in two gowns from the trousseau of Lovell and another that was donated to the Osterville Historical Society by Mrs. W. Palmer Letchford.

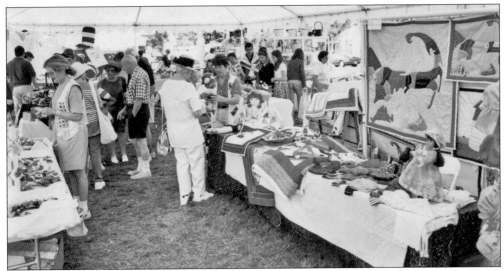

Events are often held under a tent on the library lawn, such as this arts and crafts show that offered handmade quilts, pillows, wall hangings and other unique items. These events, often held monthly during the summer, bring many people to the library lawn.

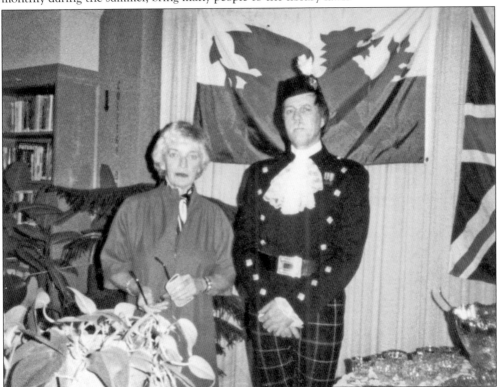

In 1983, Jean Crompton Ellis helped to sponsor a program on "Soldiers of the Queen" by B. Cory Kilvert, with a Highland soldier standing in front of one of many British regimental flags. This was a popular program on the armies of Queen Victoria from 1837 to 1901, and it had not only the colorful flags of the regiments and soldiers dressed in their uniforms but also the rousing music of Leslie Stuart's famous marching song "Soldiers of the Queen."

Kurt Vonnegut and his wife led the "Great Books Committee" and held a biweekly book discussion group at the Osterville Free Library in the 1960s when he kept a residence in the village. Vonnegut once said, "The death of a library, any library, suggests that the community has lost its soul." Thankfully, the Osterville Village Library has not just a soul, but a cadre of trustees, staff, and patrons who cherish and support it.

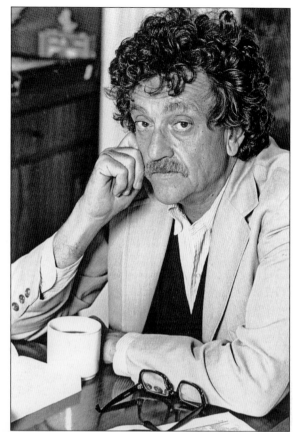

Nancy Bush Ellis (right) spoke in 1983 on "George and Barbara," a lecture about her brother US vice president George H.W. Bush and his wife, Barbara Pierce Bush. This was a great coup, as it brought in many people from across Cape Cod to hear the lecture and raised funds for the library. On the left is her sister-in-law Jean Crompton Ellis, who was a library trustee and president of the Friends of the Osterville Free Library.

Henry T. Callan spoke in 1986 on the "History of Tea," a program that outlined its ancient origins in China through to the elaborate tea drinking rituals of the 19th century. Callan was the librarian of Milton Academy, a popular lecturer on a variety of topics, and an expert antique appraiser.

Norma Hill Heyman, who served as vice president of the library trustees, cuts the cake after the lecture on the "History of Tea," which also happened to be the fifth anniversary of the Friends of the Osterville Free Library, reestablished in 1981.

Sharing conversation on the library lawn during one of the summer events are Jean Crompton Ellis (left), Mark Cote (center), and David Cudlipp.

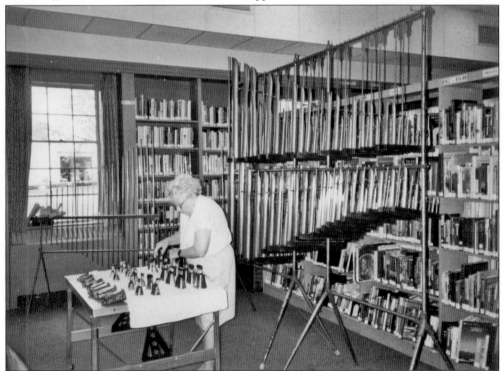

Lillian Davis presented a bell and chime concert, accompanied by Phillip Buddington, at the library in 1999. Shown here, she is arranging the handbells on which she played selections, as well as on the bell harp. Handbell ringing has long been a New England–themed event ever since Margaret Shurcliff reintroduced it to the Christmas Eve handbell concerts on Louisburg Square on Beacon Hill.

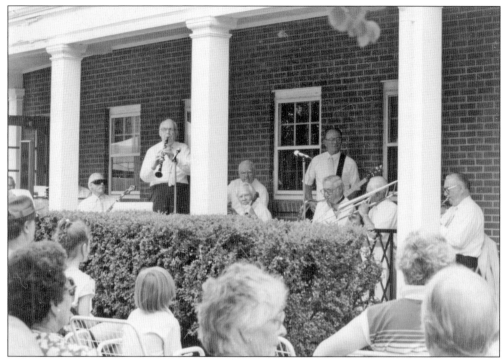

The weekly summer concerts at the Osterville Free Library bring a wide array of bands that play well-known tunes. Here, the Liberty Hall Jazz Band performs to the delight of the audience spread around the library lawn. This group performed traditional jazz concerts to raise money to restore Liberty Hall in Marstons Mills.

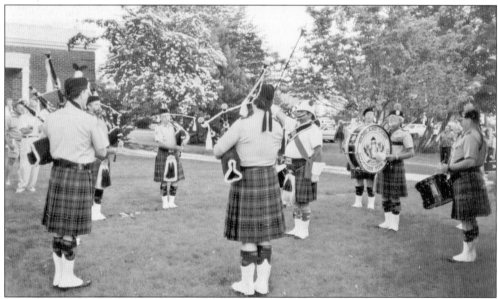

The Highland Light Scottish Pipe Band, sporting traditional kilts, performs on the library lawn in 1994. Founded in 1978, the Highland Light is the oldest pipe band on Cape Cod. One can imagine the excitement these bagpipe players created as their pipes produced a fairly high, nasal sound concurrent with a drone bass.

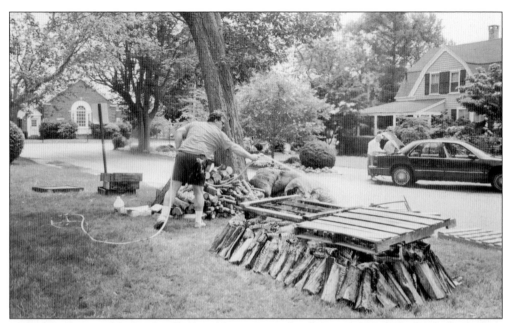

Preparing the wood log and pallet-lined burning pit for the annual New England clambake is Jim Crocker, who hoses down the wood pallets with water as the fire starts to steam the clams. Library patrons were encouraged to attend these delicious fundraisers, along "with a social hour complete with fish stories."

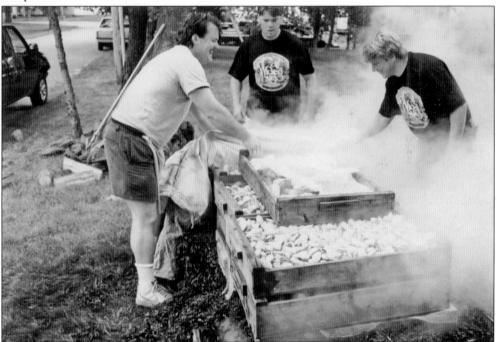

Jim Crocker (left), an unidentified helper (center), and Peter Hansen uncover the steamers that had been cooked over the wood logs, rocks, and pallets on the library lawn. These old-fashioned New England clambakes were authentically prepared with, as the invitation notes, a "full complement of seafood and vegetables cooked to perfection on heated rocks, and flavored by Cotuit seaweed."

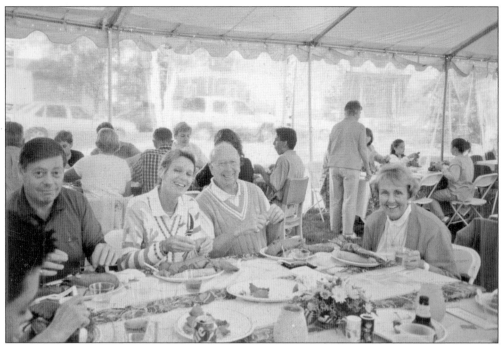

It was well worth the effort, as the annual clambake to benefit the Osterville Free Library brings library supporters as well as those who enjoy an old-fashioned clambake together under the tent on the library lawn. Seen enjoying their lobsters, steamers, corn on the cob, potatoes, and onions are, from left to right, Peter Pollock, Mary Pollock, Joe Connelly, and Margo Connolly.

While the tent is up during the annual meeting week, a variety of events are often held, including a luncheon for the members of the Friends of the Osterville Free Library.

Jean Crompton Ellis stands by the car that was part of the annual automobile raffle just before she cuts the cake for dessert after the Friends of the Osterville Free Library luncheon. The car raffle had, according to a flyer, "odds [that] are excellent and you are showing your support for the library."

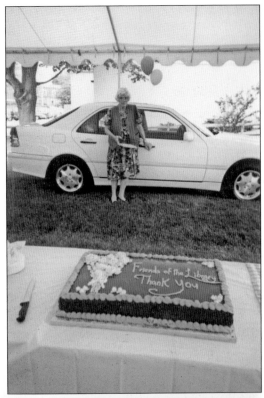

Robert J. Smith (left) and John Linehan attend the 1993 Volunteer Luncheon. Known as the "Mayor of Osterville," Smith was an educational consultant and a member of the Osterville Village Association, the Osterville Business and Professional Association, and the Osterville Rotary Club and a trustee of the Osterville Free Library. Linehan was a trustee of the library and active in its support.

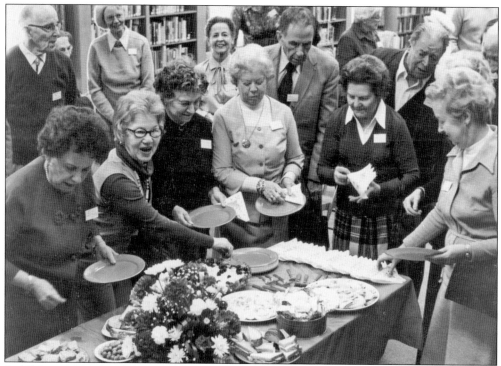

In 1980, a potluck luncheon was held for library volunteers in the North Room. A library survey documented that library patrons find "the library easy to use and the staff very helpful and courteous" and the volunteers felt extra special at these events.

Following the potluck luncheon, the flowers that had decorated the table were won by Mary Dee Schmonsees.

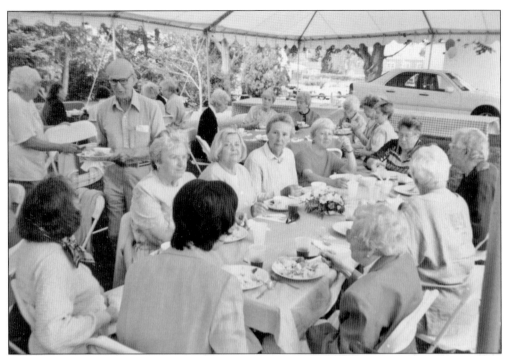

A Friends of the Osterville Free Library luncheon in 1980 brought many whose efforts assisted the library throughout the year. Among those at the table are library trustee Peg Mullin, Ann Plescia, and O.J. Plescia.

This holiday gala in 1984 includes members of the Friends of the Osterville Free Library, many of them sporting plaid blazers and trousers, enjoying libations before the dinner. These events had a cash bar and "Elves' Nibbles," making for a convivial and enjoyable event.

Enjoying lunch at the Friends of the Osterville Free Library luncheon in 1983 are Barbara Baker (left) and Gail Nightingale. Candlelight, flowers, and a delicious lunch were offered as a small token of appreciation for the myriad things volunteers did to support the library.

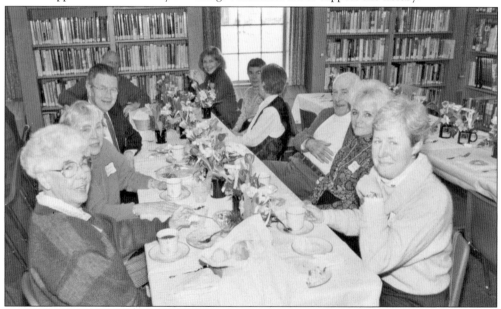

A volunteer luncheon in 1994 had tables laid with spring flowers in the North Room. These volunteers provided all kinds of help, including shelving books, repairing books, typing, filing, and other innumerable things that help the library operate smoothly. Among those at the table are Barbara and Warren Hansen, Ginger Stimets, John and Mary Linehan, and Sheila Thomas.

Frankie Hornig (left), Pamela Jacques (center), and Melissa Jacques are seen at the library. In a survey from 1977, the average woman who used the library is said to "read for recreation, mostly fiction (148) with non-fiction (109) a close second and she uses [the library] copy machine while she is here (103). She is very satisfied with this area of the library (186). We reserve books for her (101) and she requests many inter-library loans (107), but she does not use our study area (126 do not use to 31 that do)."

An unidentified library patron (left) and Jean Crompton Ellis share a laugh at the friends' book sale at the library. The friends not only sold both deaccessioned and donated books to raise money for the library but also helped at fundraising activities and donated subscriptions to both local Cape Cod newspapers and magazines, as well as the New York Times. Ellis was not just a volunteer but also an accomplished writer and once freelance film critic for the Office of Film and Broadcasting of the US Conference of Catholic Bishops.

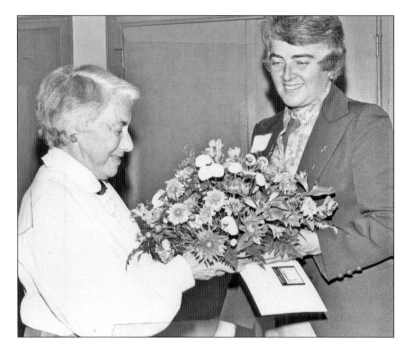

Betty Bliven (left) is presented with a floral arrangement from Gail Nightingale, who represented the library trustees. With over 10 years of volunteer service to the library, the longest at that time, Bliven's dedication was greatly appreciated.

Carrie Murphy often provided musical entertainment at library events. Shown here in 1987, she plays piano selections during tea hosted by the Friends of Osterville Library at its open house.

Catherine Ellis plays Christmas carols on the library piano at the Friends of Osterville Free Library Christmas party in 1984, accompanied by a quartet of musically inclined members of the friends group.

Another popular entertainer at these holiday events was Payton Daniel, a student at the Berklee College of Music in Boston, who, in 1983, played the library piano at the holiday bash.

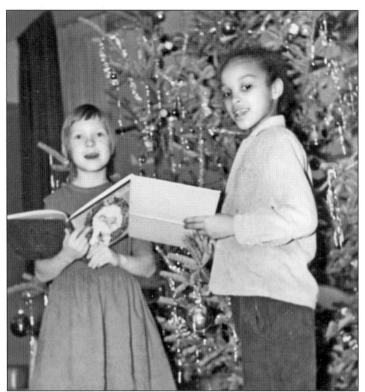

Singing Christmas carols under an old-fashioned, tinsel-bedecked Christmas tree at the library in 1963 are Lynda Hegbug (left) and Darlene Alves.

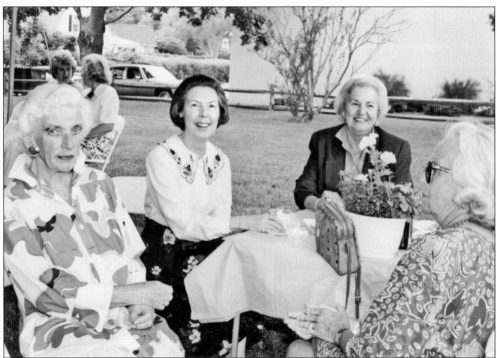

The 1994 summer celebration had friends enjoying libations at tables set up on the library lawn. From left to right are Jean Crompton Ellis, Ann Colgan Gillis, Frances Gray, and Margaret Wyatt.

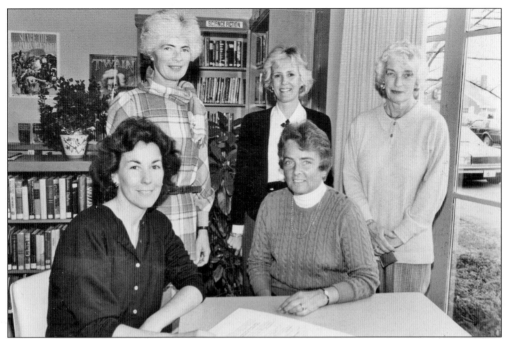

Members of the fashion show committee in 1986 are, from left to right, (seated) Carolyn Crawford, and Gail Nightingale; (standing) Martha Curley, Sue Ferriman, and Jean Crompton Ellis. These fashion shows were fun to attend, and the large number of people that came ensured that it was of great financial support to the library.

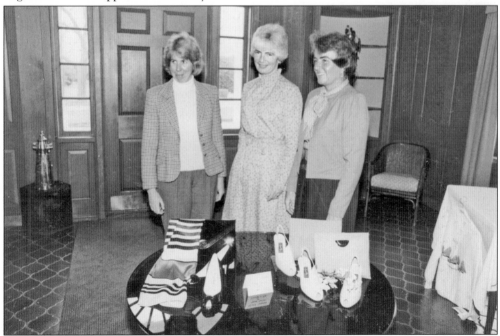

At the fashion show, a table laden with accessories such as scarves, shoes, and handbags is admired by, from left to right, Mary Wells, Martha Curley, and Gail Nightingale. These annual fashion shows had lovely luncheons at either the Wianno Club or the Oyster Harbors Club.

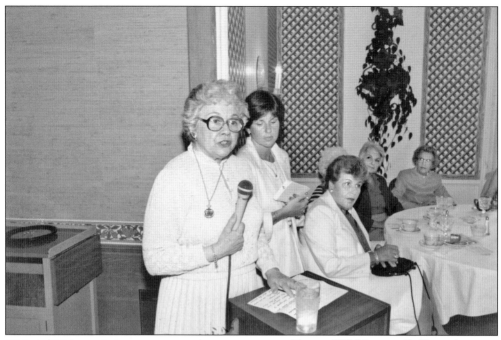

Norma Hill Heyman (left) speaks at the spring fashion show at the Oyster Harbors Club in 1985, with Joan Witter (center) and Yola Cappucia (seated in the foreground). These fashion shows, though a delicious luncheon and an enjoyable afternoon with many fashions shown to those in attendance, were a vitally important part of raising funds for the ongoing support of the Osterville Free Library.

Ann Colgan Gillis models a Lilly Pulitzer dress at the 1985 spring fashion show that was held at Oyster Harbors Club. These designs featured bright, colorful, floral prints, and Gillis wore the dress with great éclat.

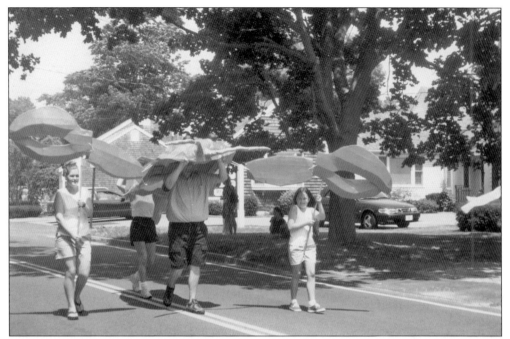

During Osterville's Village Day, there are often unusual but highly appropriate local-themed entries, such as this enormous papier-mâché red lobster with truly larger-than-life claws that is held aloft by four volunteers and paraded through the village.

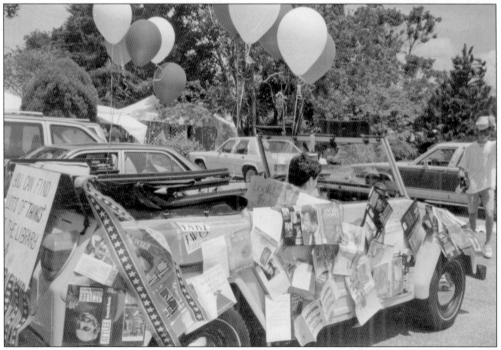

During Village Day in 1992, the Osterville Free Library entered a balloon-and-magazine-cover-bedecked convertible in the parade that had a sign on the rear that read, "You Can Find Lots of 'Thinks' at the Library."

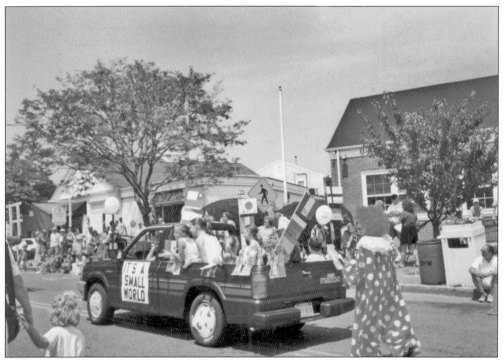

The Village Day Parade in 1999 included a truck with young library patrons holding the flags of various countries around the world with a sign that read, "It's A Small World." It really is after all, and Osterville is the epicenter of that small world.

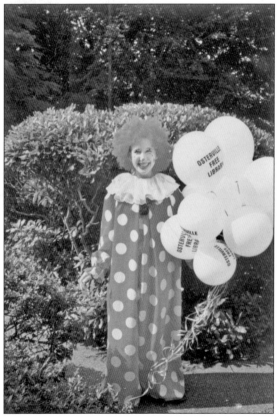

Melissa Jacobson is dressed as a clown, replete with a red wig and an unusually large polka-dot outfit, during the Village Day Parade in 1999. The balloons she holds are imprinted with "Osterville Free Library" and would be given out to children along the parade route.

During the 100th anniversary of the Osterville Free Library, an elegant tea was held in 1981 in the North Room of the library. Here, Peg Mullin, chairman of the Massachusetts Board of Library Commissioners and a former library trustee, pours tea for Janice Mitchell.

Soloist Grace O'Connor was accompanied by Cynthia Gordon on the harp for a concert of arias and other musical selections during the centennial events of the Osterville Free Library. The concert included "Orpheus with his Lute" by William Schuman, "Serenade" by Franz Schubert, and "Beau Soir" by Claude Debussy.

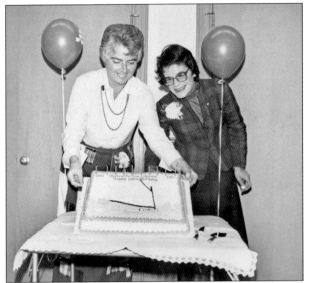

Admiring the 100th anniversary cake of the Osterville Free Library are Gail Nightingale and Betsy Saunders Hornor. The sheet cake had a Crosby catboat on the top, which has long been the bookplate of the library and is now the weather vane that surmounts the present library roof.

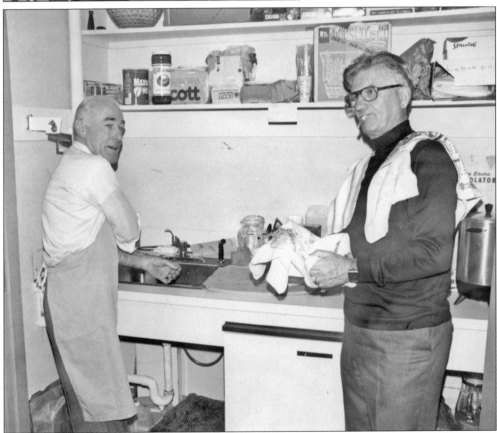

Of course, after every party, there has to be a cleanup crew to wash the dishes and put everything back in order. Here are John Linehan (left), washing plates in the sink, and Chet Heyman, drying them. Volunteers come in every size and shape, and they are an important part of the library activities.

The Osterville Garden Club donated and decorated an "Early American" Christmas tree to the Osterville Free Library in 1971. Ropes of strung popcorn, paper cones filled with sweetmeats, and gingerbread men and women decorate the tree, which was placed in front of the bay window in the adult lounge facing Wianno Avenue. Here, Eleanor Carey Tongberg of the garden club poses in front of the Christmas tree.

Bucky Ray (left) and Jeff Groff man the bar at the Friends of the Osterville Free Library Christmas party in 1988. Potent libations always seem to make a party a success.

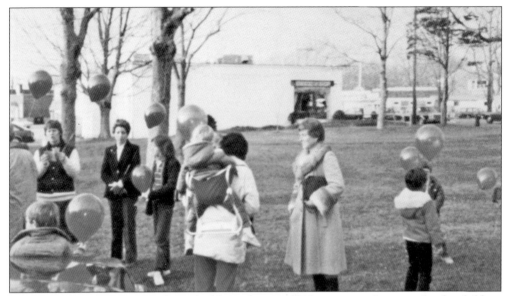

The singing of Christmas carols on the library lawn in 1988 was a popular event for the children of the village. With adults and children bearing balloons, the carols added a festive touch to Osterville Village.

Ernest Dewitt (center) attended the Friends of the Osterville Free Library Christmas party in 1987.

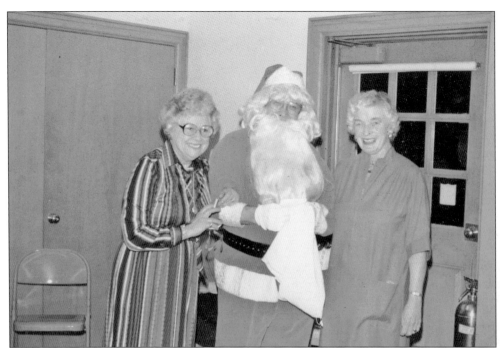

Santa Claus came from the North Pole to attend the Friends of the Osterville Free Library Christmas party in 1984. Shown here, he is flanked by Norma Hill Heyman (left) and Jean Crompton Ellis.

Betty Burns and Santa Claus embrace during the Friends of the Osterville Free Library Christmas party in 1988. Obviously, he was not just a figment of a child's imagination, arriving just in time to share in the conviviality of the Christmas party.

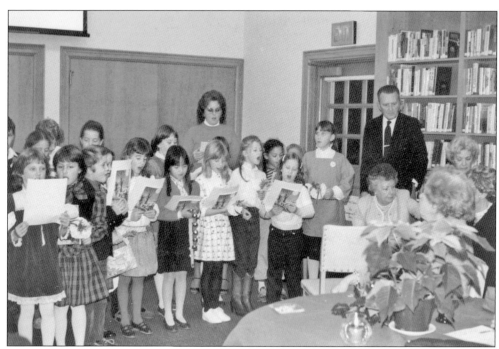

Entertaining at the 1984 Christmas party was a group of children who sang Christmas carols accompanied by the many Friends of the Osterville Free Library. On the right is Victor Adams, the chairman of the board of Barnstable Selectmen and an Osterville resident.

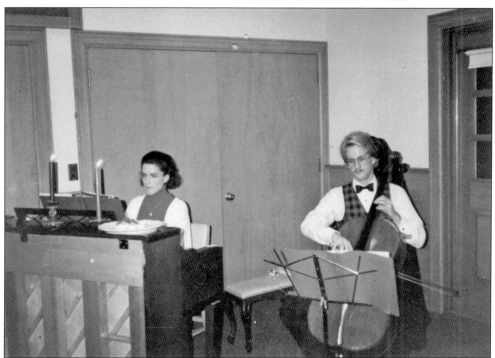

Karen Crosby, at the piano, and Eric Dahlen, with his bass viol, provided musical selections during the annual Christmas party of the Friends of the Osterville Free Library in 1988.

*Four*

# FRIENDS OF THE LIBRARY

Volunteering at the Osterville Village Library is not only fun but also integral to raising the necessary funds to operate the library. Though a portion of the annual expenses come from the Town of Barnstable and part of the operating revenue comes from either endowed funds or the income from investment funds, it is primarily raised by committed members of the Friends of the Osterville Village Library and annual donations.

One of the biggest coups for the library was when trustee Jean Crompton Ellis invited then first lady Barbara Pierce Bush to come to speak at the Osterville Free Library. Ellis (right) was the sister-in-law of Nancy Bush Ellis, the sister of then president George H.W. Bush, so her family connections made for a star-filled and extremely well-attended day.

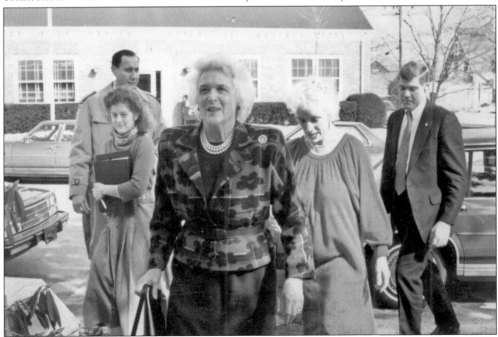

First Lady Barbara Pierce Bush, accompanied by Jean Crompton Ellis (right), Bush's secretary Peggy Swift (left), and two Secret Service agents, arrives at the library to greetings from a large group of Ostervillians and library patrons. The first lady spoke for 15 minutes and commended the Friends of the Osterville Free Library for fighting illiteracy through making books an important part of the village's life.

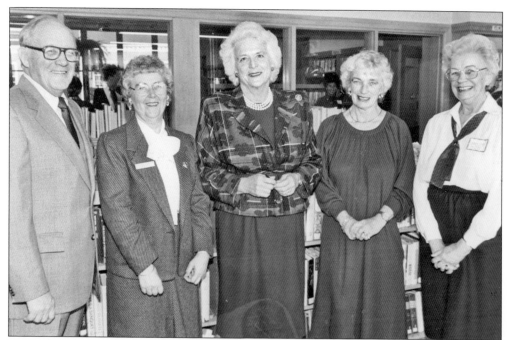

Posing for a group photograph to commemorate the occasion of First Lady Barbara Pierce Bush's visit to the Osterville Free Library are, from left to right, Lyman Avery, president of the library; librarian Barbara Baker; Bush; library trustee Jean Ellis; and Margaret Wyatt, president of the Friends of the Village Library.

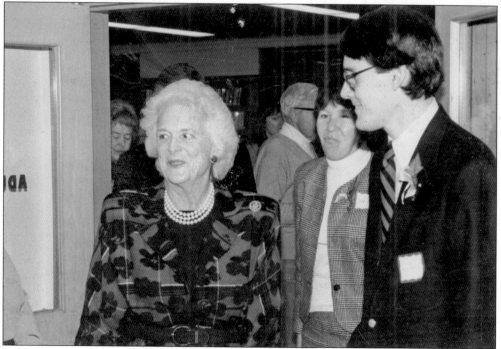

Barbara Pierce Bush, ever the regal lady with her trademark pearls, smiles as she greets library patrons and supporters while accompanied by library trustee Jeff Groff.

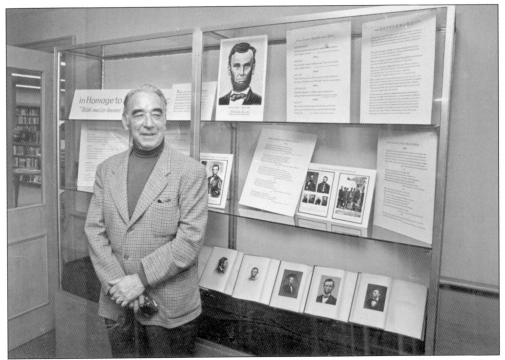

The Osterville Free Library has often had interesting exhibits in the glass display cases. Here, Charles Dibner helped to create a display on Abraham Lincoln, the 16th president of the United States, in February 1980.

Posing in front of the glass display cases in 1979 are Frankie Hornig (left) and Mary Thayer, who created the models of famous 19th-century clipper ships that are on view. Shipbuilding, whaling, and trading were vital parts of the economy of Cape Cod in the mid-19th century.

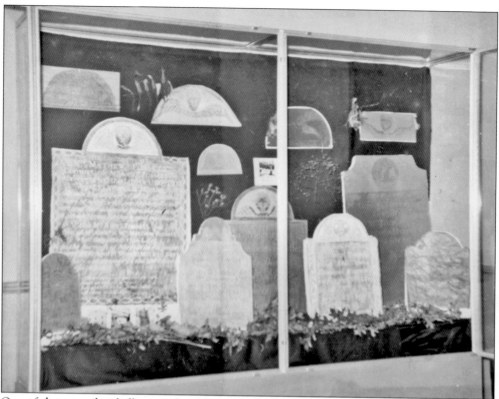

One of the more decidedly outré local history exhibits at the library was a group of gravestone rubbings done by Frankie Horning from the 19th-century headstones at the Hillside Cemetery in Osterville. The exhibit, which showed skulls and crossbones, winged angels, and epitaphs of Ostervillians from a century previous, was appropriately held in October 1978.

In December 1978, Frankie Horning created a Christmas display for the glass cases, with a festively decorated felt tree, a Nativity scene, and Christmas stockings hanging and ready to be filled by Santa Claus.

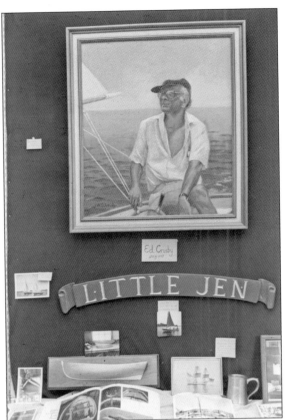

A memorial exhibit for Edward Crosby was held in July 1979, complete with his portrait, showing him at the helm of his catboat *Little Jen*, and an interesting display of half hulls, books, and ephemera dealing with his involvement with the famous Crosby Boatyard in Osterville. The exhibit was mounted by Frankie Hornig, who said that by "doing the exhibit for Ed, talking to his mother, family, and friends, I came to know, understand, and admire a great man."

The annual car raffle, started by the Friends of the Osterville Free Library, goes through the summer months, with tickets being sold to hopeful winners of a luxury automobile. John and Mary Linehan are on the left, purchasing a raffle ticket from Sue Jacobsen and Nancy Cudlipp (in the straw hat).

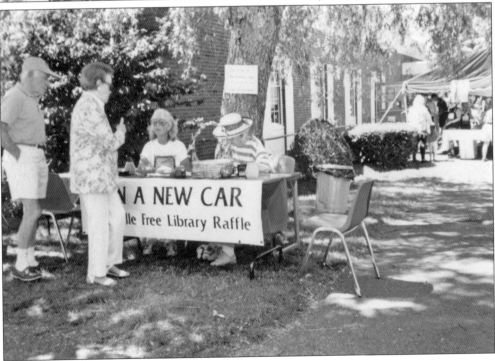

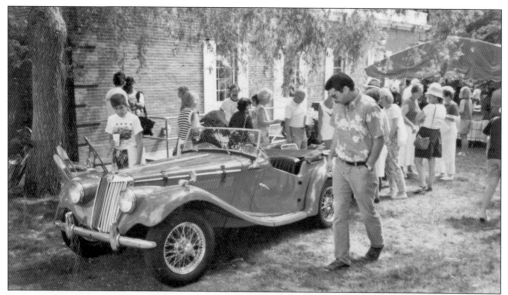

Parked adjacent to the library, this vintage 1955 MG TF Model 1500 was donated in 1987 by James H. Crocker to the Friends of the Osterville Free Library to be raffled to raise funds for the library. The Classic Car Raffle attracted great attention from car aficionados from not just Osterville, but also across the commonwealth of Massachusetts. Admiring the car is Ed Lacey.

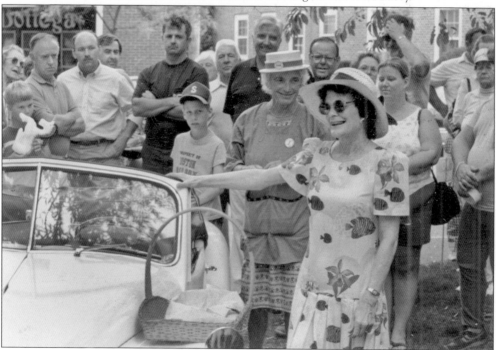

Betsy Saunders Hornor (right) and Jean Crompton Ellis, in a straw boater hat, stand by a 1955 XK 140 Jaguar Convertible, known as a drophead coupe, that was donated by James H. Crocker, a library trustee. Chances for this classic car raffle were actually brass key rings, engraved and numbered, and there were only 200 chances at $100 apiece, which sold out within a week. The lucky winner of the car was Jerry Butera of Centerville.

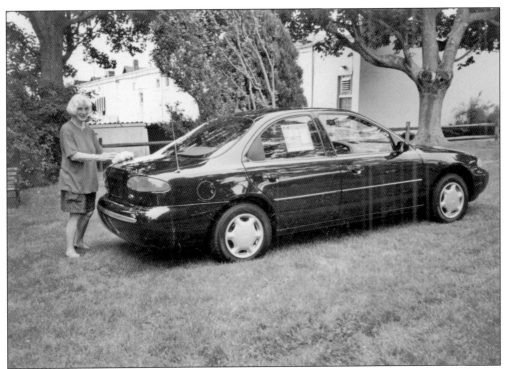

Jean Crompton Ellis polishes the automobile to be raffled in 1995, hoping that a clean and shining car will sell additional raffle tickets and thereby raise even more funds to support the library.

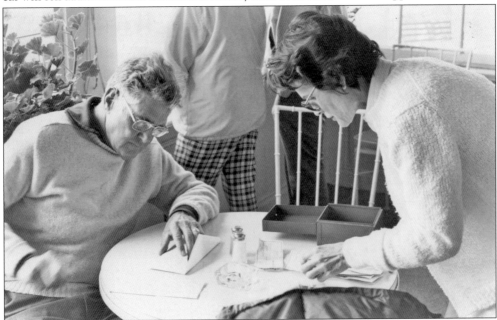

The annual golf fundraiser at the Wianno Golf Course is a major effort by the library. Here, Skip Batchelder, a library trustee and an educator at the Cape Cod Academy, and Betsy Saunders Hornor are adding up the midday receipts during the seventh annual golf classic at the Wianno Golf Course in 1982 to benefit the library.

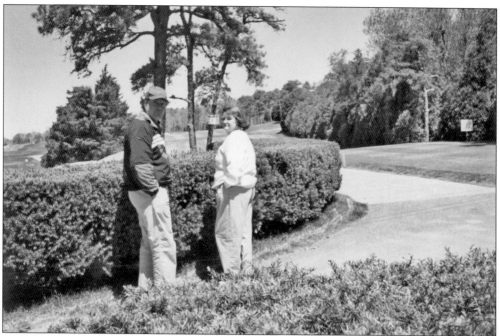

Standing at the sweeping entrance to the Wianno Golf Course are Mark Cote and Cindy Cote. The 1994 Wianno Golf Classic brought golfers from near and far to play the wonderful course, which traces its roots to the great golf course designer Donald Ross, who laid out a nine-hole course. The golf course literally embodies the windswept nature of coastal golf in New England.

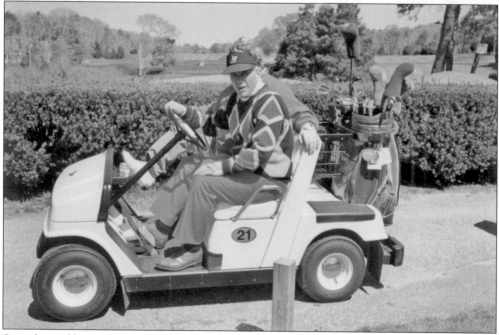

Seated in golf cart No. 21 in 1994 is Bob Bownes, wearing a festive golf outfit, with his golf bag and clubs secured on the rear. The 18-hole golf course designed by Donald Ross opened in 1916 and features 5,900 yards of golf from the longest tees for a par of 70.

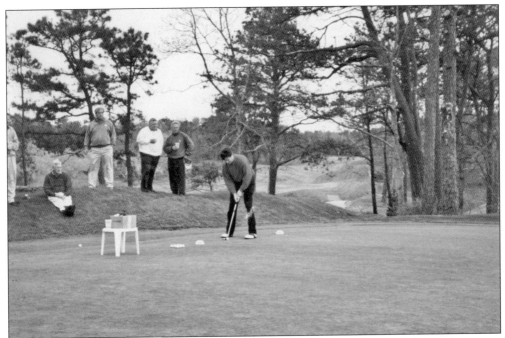

A golfer, with dozens of golf balls perfectly aligned, practices his swings on the putting green before the golf classic got underway. The golf course has a 15-tee driving range with 18 regulation holes; the course rating is 68.3, and it has a slope rating of 117 on bent grass.

Watched by the golf entrants along the embankment while he readies his swing is one of the many golfers who not only enjoyed the fabled Wianno Golf Course but also supported the Osterville Free Library through his participation. In 1919, Donald Ross was hired to redesign the original nine and create a new nine. In 2013, architect Gil Hanse added seven new bunkers throughout the golf course.

Geoff Lenk and Barbara Conathan wait for the golfers to return from the golf classic for a cool drink and to record their scores on the board before the prizes are awarded.

Ed Lacey won a putter in the raffle and could not seem happier. On the right is Rick Clark.

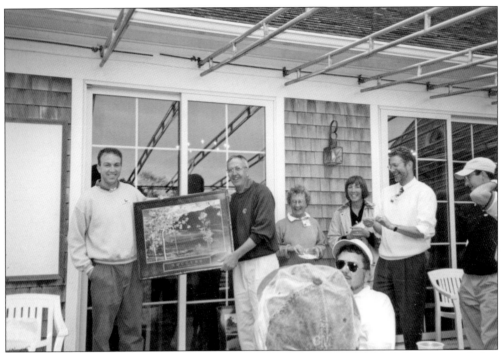

Holding a large famed picture of the golf course with the nameplate "Success" that was awarded in the raffle are, from left to right, Rick Clark, John Conathan, Barbara Conathan, Ellyn Osmond, and Geoff Lenk.

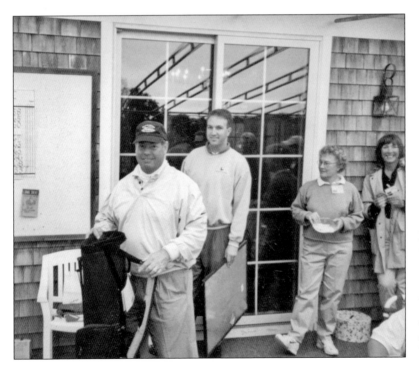

Proudly holding the golf bag he won in the raffle is Peter Pollack. Behind Pollack are, from left to right, Rick Clark, Barbara Conathan, and Ellyn Osmond.

*Five*

# CHILDREN'S ACTIVITIES AND EMERGING LEADERS

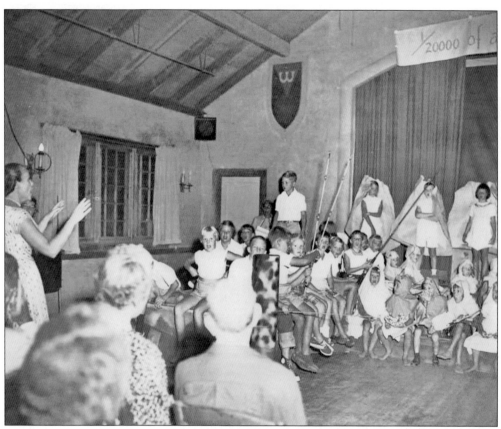

The Osterville Free Library often presented plays during the summer months, with numerous local children participating and with Betty Kilborne, Sally Rowland, and Carolyn Rowland establishing the program. Two years later, they added a tradition that continued through the 1950s and into the 1960s: *The Wianno Musical.* Betty Kilborne wrote the musical for the children to perform in the ballroom of the Wianno Club on Labor Day weekend. Tickets were sold by the performers, and the proceeds were given to the Osterville Free Library.

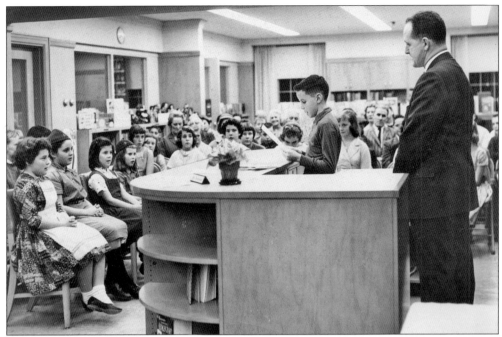

Don Carpenter, reading from his prizewinning essay to his fellow youngsters, was one of ten winners in the Osterville Free Library essay contest held in observance of National Library Week in 1960. On the right is Richard C. Macallister, president of the library trustees, who oversaw the event.

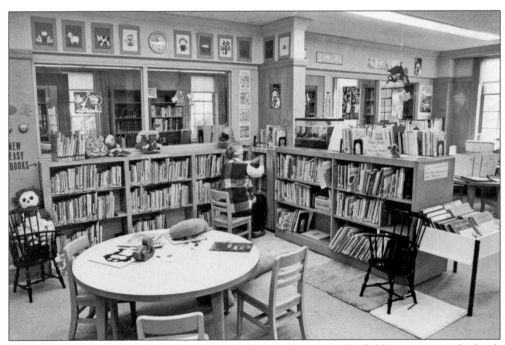

The Children's Room had shorter book stacks that made it easier for children to peruse the book collection, and round tables and chairs for young patrons of the library. Here, a librarian shelves books that were often used.

Librarian Margaret Frazier reshelves books with the assistance of Thomas Frechette and Rose Marie Cain, who acted as pages during the November 1963 National Children's Book Week. They were third-grade students at the Osterville Elementary School, and they and other classmates served as library pages that week.

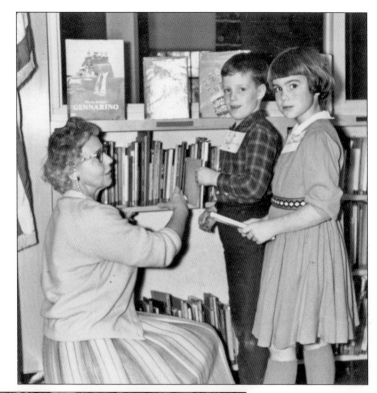

Children's fiction books seemed to have been the rage in 1978, with Kevin Gould (left) and Steve Lyons looking over the library collection. The two boys were students at the Cape Cod Academy who helped to reshelve books at the library on their lunch break.

Mrs. Edward N. Winslow was the well-known maker of "Storybook Cookies," and her cookies became a legend on Cape Cod. Shown here during National Library Week in 1965, she regales the young patrons of the library with her cookie characters and the stories that they represent, with the anticipation of the Storybook Cookies being served afterwards.

Chris Morrissey reads through various back editions of *Newsweek* magazine to prepare for a composition that he was writing on Pres. Jimmy Carter's administration. The library was a place not just to borrow books but also to peruse many of the magazine subscriptions that helped in doing homework and other assignments, as well as providing reading enjoyment.

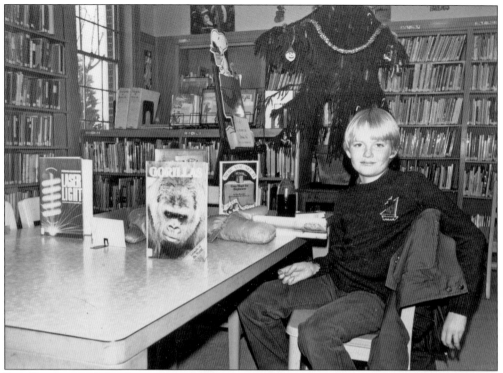

Ray Hutchins said that he went to the library "all the time . . . to eat and read." Here, he sits in the Children's Room with a selection of suggested books one might enjoy.

A kite festival was first held at Dowses Beach in 1977. Though many children made their kites at the library at a kite-making afternoon and flew them, this youngster sits in her chair seemingly oblivious to the kites flying high above.

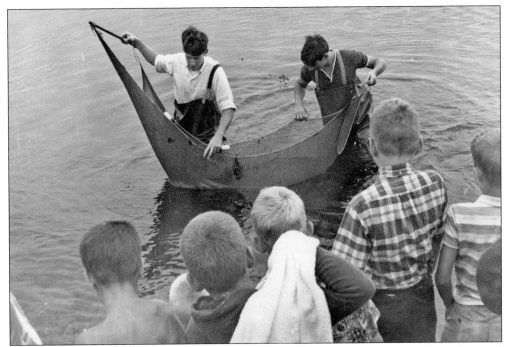

Marshal T. Case (left), a graduate of Cornell University with a degree in wildlife biology and science education, shows a group of children from the library how to properly hoist a net to catch fish at Dowses Beach in Osterville. These field trips were not only fun but they also expanded the knowledge of these young naturalists and were led by the author of *Look what I found!* and curator of the Cape Cod Museum of Natural History Museum in Brewster, Massachusetts.

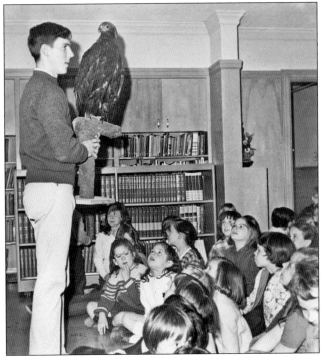

Marshal T. Case holds a stuffed falcon on a wooden perch as children gaze up in amazement at this bird of prey. The visits by members of the Cape Cod Natural History Museum were often fascinating glimpses and stories of the wonders of natural history.

*Fiction Friction* was the brainchild of Marjorie Lenk of Cellar Door Cinema, whose award-winning film was said "to allow children to reveal their innermost nature, to guide them in the visual translation to film, [and] is perhaps the only valid reason for having 'Cellar Door Cinema.' Lucky children, lucky library, lucky us!" From left to right are Linda Pierce, librarian Margaret Kyle, Mary Collins, Susan Pierce, and Gretchen Blake.

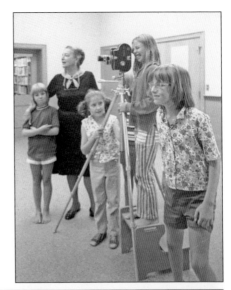

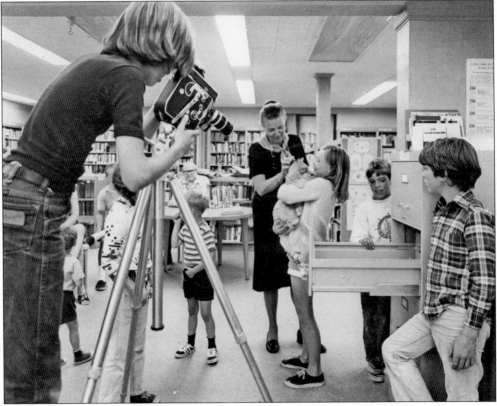

Being filmed by Steve O'Brien is librarian Marjorie Kyle, patting a cat held by one of the cast members of *Fiction Friction*. In 1972, the John Cotton Dana Public Relations Award and the Yellow Ribbon at the Baca Film Festival were awarded to the film, which was described as a "combination of animated art work and pixilated scenes of familiar faces charging the library doors at sunrise, gyrating in the South Room, borrowing countless odds and ends from the completely unstereotyped librarian, chasing stray pets, and rushing madly to the lavatory."

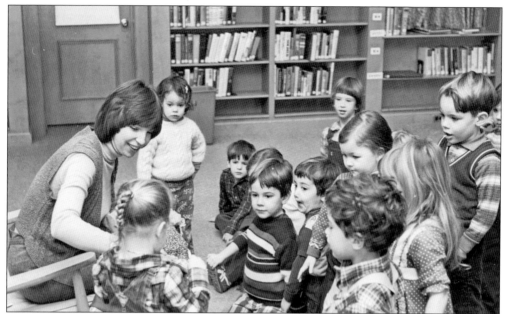

Eileen Hurley reads to a group of young children at a library storytelling in 1972. Reading, as well as showing visual images in the book being read, allowed the children to hear and see the story and thereby develop audio and visual abilities. Hurley was the winner of the Young Career Woman of 1979, a great honor. Among the children at this weekly Friday afternoon event are Megan Mahoney, Neil Mahoney, and Guy Riedell.

Of course, storytelling hours were 60 minutes long, and though the children undoubtedly enjoyed their time with the children's librarian, this photograph of the waiting mothers tells another story. Here, in 1980, a group of mothers awaits their children as they sit around one of the small tables, smoking and chatting to while away the time—smoking was once allowed in public buildings.

Members of the Junior Garden Club met at the library in 1980 to not just start seeds for spring planting but also to enjoy one another's company. Under the leadership of Eleanor Carey Tongberg, who was president of the Osterville Garden Club, the children ranged in age from nine to thirteen and learned horticulture, worked with flowers, and made flower arrangements.

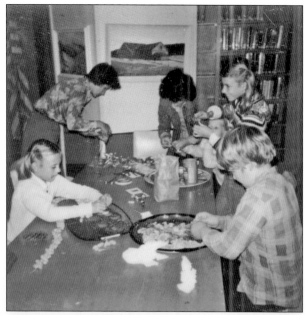

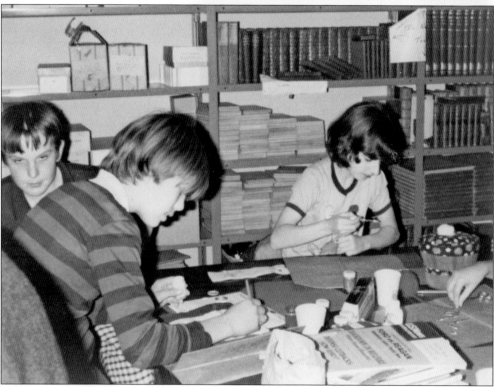

The Bicentennial Tails, a kite-making mini course with instructors Eileen Hurley and Sarah Davis, was held at the library in 1976; the kite crafters are, from left to right, Scott Nightingale, James Murphy, and JoAnne Avallone. These kites were flown at Dowses Beach to celebrate the 200th anniversary of the United States and drew kite watchers and fliers alike to participate in the event.

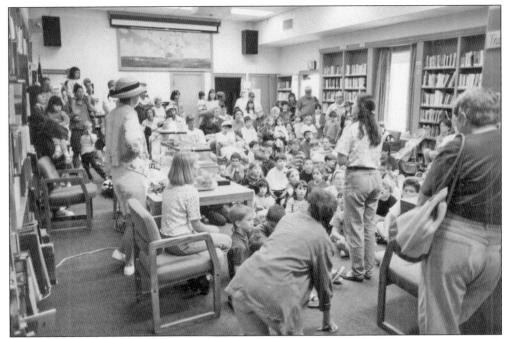

A staff member from the Cape Cod Museum of Natural History speaks to a standing-room-only crowd of children as well as adults in the North Room at the library in 1990. Of course, it might have been her topic, which was on snakes and reptiles, that brought curious children and adults alike to not only hear of their habitats but also to see them in their reptilian flesh.

Ginger Brearton was a well-known puppeteer who presented her shows as "Gigi's Puppets." Here, she entertains children at the library in 1968 with the puppet show "Sookie the Seal Who Went to School."

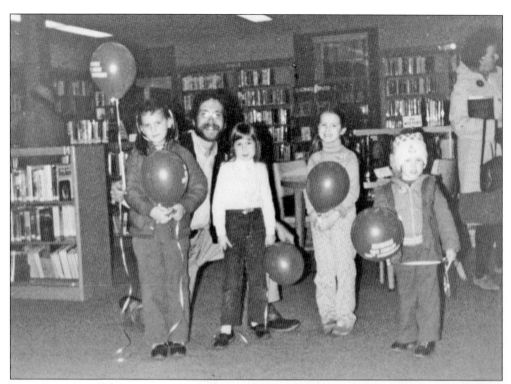

Davis Bates, a well-known storyteller, came to the library in 1982 during the centennial celebrations for the library. Bates often performed a mixture of family, Native American, international, and regional stories and songs. Here, a group of children poses with him holding red balloons that were given out to celebrate the event.

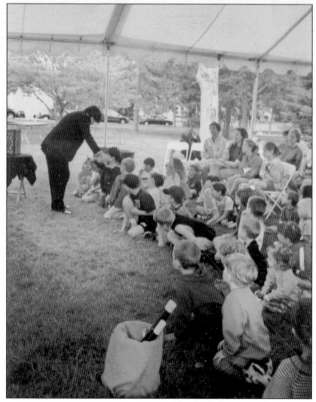

A magician entertains a cadre of children under the tent that had been erected in 2013 for the annual meeting and events that week. Usually to the delight of children, a magician performs by creating the illusion of impossible or supernatural feats to the incredulity of not just children but also adults. One wonders just how he did that trick.

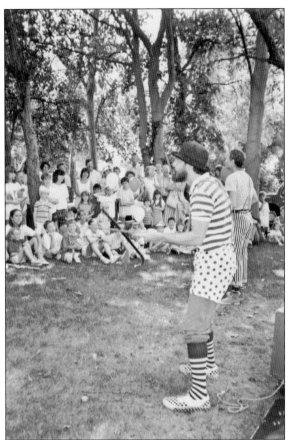

The Suspenders Juggling troupe had a wildly dressed juggler entertaining children on the library lawn; from tossing balls or oranges to walking canes (as in this case) into the air, the jugglers were always a big hit—so long as they caught their objects. Skilled in keeping several objects in motion in the air at the same time by alternately tossing and catching them, jugglers have entertained for centuries.

Carl Mitchell of the Cape Cod Miniature Society, seen in his studio, built and furnished the Walker House, a Victorian dollhouse that was donated to the Children's Room of the Osterville Free Library. Every September, the society has a Fun Day that includes workshops in dollhouse furniture and accessories, plus an in-house flea sale and silent auction. This elaborate dollhouse, with wonderful miniature pieces of furniture, has delighted children for many years.

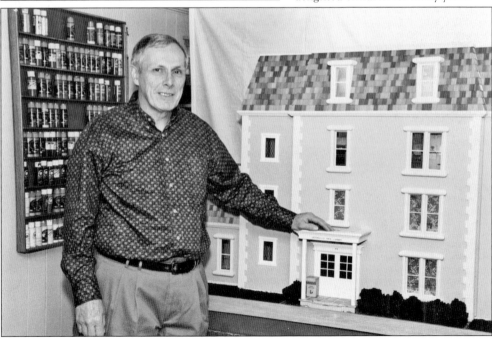

# Six

# LIBRARY STAFF, FRIENDS, AND VOLUNTEERS

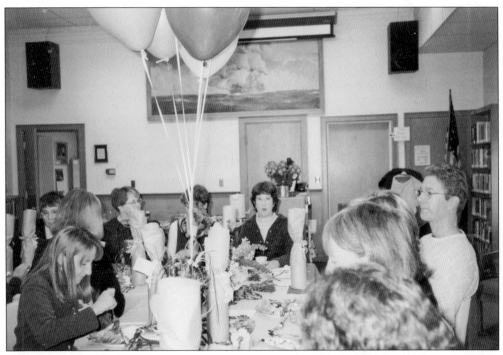

A staff and volunteer luncheon at the Osterville Free Library in 1999 had colleagues enjoying a festive lunch with balloons, floral arrangements, gift-wrapped wine bottles, and delicious food. Among those at the table are Melissa Petze, Eileen Cashin, Megan Mahoney, Marleen DiNicola, and Geoff Lenk. The library staff has always been dedicated and professional, and by the turn of the 21st century, it was larger than it had ever been.

In 1985, members of the Friends of the Osterville Free Library met to discuss how they might assist the library through book sales, bake sales, and other fundraising activities. From left to right, Vickie Gibson, Norma Hill Heyman, and Eleanor Noonan are enjoying a coffee break after their meeting.

Norman Baldwin was a library volunteer in the 1980s. Here, he processes paperwork, which was a great help and a necessary job at the library. He said, "I'm here for the normal use of the library, and to use this very good copying machine for a technical article."

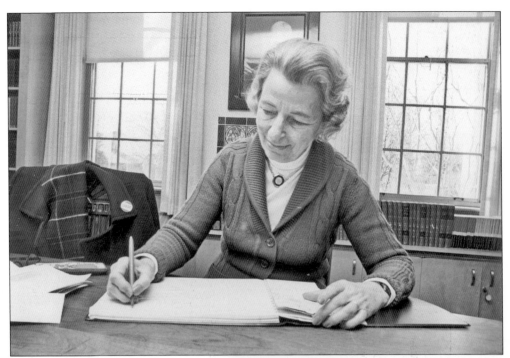

Isabelle Marckwald Bushnell served as the assistant treasurer of the Friends of the Osterville Free Library for many years. While living in Osterville, she was elected a town meeting representative for Osterville during the years 1977, 1978, and 1979 and also served as library trustee.

Betsy Saunders Hornor was a library trustee and devoted public servant. She served as president of the Osterville Village Association, chairman of the Town of Barnstable Youth Commission, and director of the Cape Symphony Orchestra, the Nickerson Society, MSPCC, and Three Bays Preservation, Inc.

Making plans for a series of upcoming events at the Osterville Free Library are, from left to right, library trustee Noel MacInnes, librarian Barbara Baker, and assistant librarian Jane Hoffman.

Doing research in the Reference Room in pre-Google days are Claudia Morner (left) and Patricia "Pat" Avallone. The card catalog and encyclopedias of the past were a way of researching a topic before the days of the Internet. This room was also used for history programs and temporary art exhibits.

Pat Avallone (left) and librarian Barbara Baker are shown manning the circulation desk at the Osterville Free Library. Avallone also spearheaded, with Sean Neath, "Disco In the Library" in 1980, with a series of dance lessons for young adults at the library. Disco fever descended on Osterville Village with a vengeance after the library closed for the night.

Jane Hoffman Kenney served as the children's librarian in the 1980s and would later become librarian for the Barnstable Public Schools.

Assistant librarian Pat Avallone (left)
and Katey Hutchins share a laugh as they
prepare a new book catalogue for the
library. Hutchins also updated the library's
bulletin board displays in the early 1980s.

John A. Kerig served as a summer library
assistant in 1979 and 1980. Though he was
studying at Colorado College where he also
worked in the library, he returned to Osterville
to work in the library and, according to a
library newsletter, "to the joy of all concerned
[came] back for a second summer." "Although
he enjoys his work in the Library, he is open
about the future" of a career in library science.

Wendy Taylor, with her hands full of library books, obviously did yeoman's duty at the library in 1978, carrying books that need to be reshelved. A graduate of Barnstable High School, she volunteered at the story hour for the children before becoming a part-time member of the library staff in 1980.

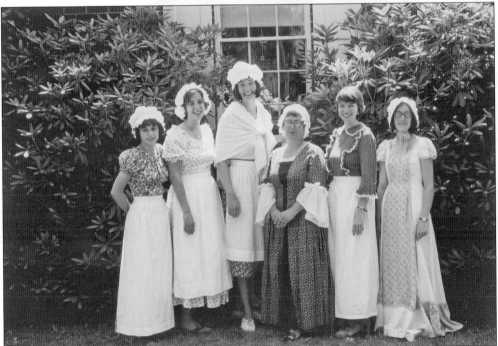

Members of the library staff and volunteers got into the spirit of the bicentennial of the United States in 1976 and dressed in Colonial garb and mobcaps for a group photograph in the garden. From left to right are Patricia Avallone, Sara Davis, Claudia Morner, Barbara Baker, Eileen Hurley, and Cathy Crosby.

Sean Neath was a part-time staff member at the library in 1981 and kept everyone abreast of what the youth of Osterville wanted and expected from the library. A newsletter article states that he also "left his mark in the young people's program, helping to organize an information bulletin board and direct a disco dance program in the evenings."

Ruth Hiebert Davis, the wife of Joel Davis, was active at the library as both a trustee and dedicated volunteer. She also served as the chair of the library building and grounds committee, so she was often at the library interacting with staff and patrons. Active in volunteerism, she also served on the boards of the Cape Cod Symphony and the Early American Glass Club.

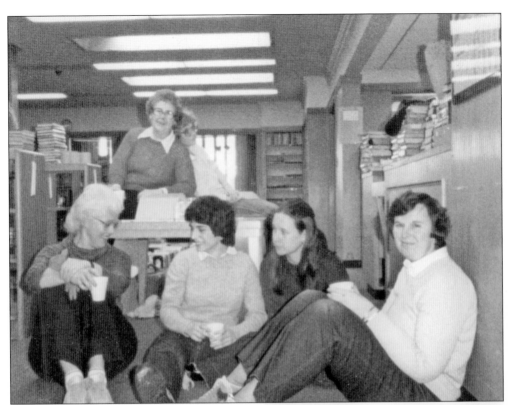

In 1984, there were extensive renovations to the library and quite a bit of disruption while the work was being done. Here, the library staff takes a break from moving the books back to the stacks. Pictured are, from left to right, (rear) Barbara Baker and Katey Hutchins; (foreground) Reba Luke, Patricia Avallone, Gail Nemetz, and Jane Hoffman.

Modeling the new library T-shirt depicting the *Wianno Senior* is Isabelle Bushnell, the assistant treasurer of the Friends of the Osterville Free Library. She carried her nautical-themed outfit to include a skirt that features a blue-print embossing of sailboats. This 1977 fundraising effort served the perfect need for a gift or stocking stuffer that year.

Ron Murphy served as a trustee of the Osterville Free Library in 1980. An educator at Dennis-Yarmouth High School, he was also a sculptor of some renown and brought both education and the arts to the forefront of the library's outreach programs.

Gen. James M. Gavin served as a trustee of the Osterville Free Library in the 1980s. Best known as the commander of the 82nd Airborne Division, the first such airborne unit during World War II, he authored an instructional manual on airborne tactics and was respected by his troops. A monument honoring him is at Veterans Memorial Square in Osterville Village.

Jana Campanella (left) and Beth Crane stand in front of an old-fashioned roasted peanuts and popcorn cart owned by Donald "Ducky" Crocker that was set up on the lawn in the summer of 1986 to provide snacks to those attending the concerts on the lawn.

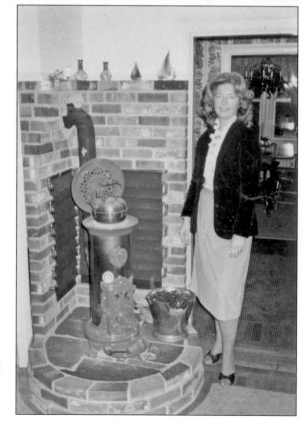

Sue Hansberry Jacobson was a trustee of the library in 1981 and an active volunteer. A library newsletter reflects that "our library has benefited greatly in the past from much of Sue's volunteer work in bake sales, luncheons, and village day auctions."

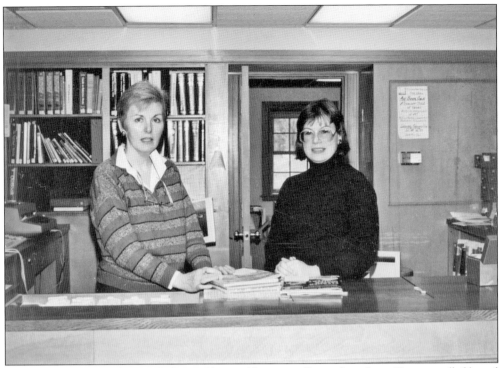

Standing at the circulation desk in 1991 are library staff members Jean Haggerty (left) and Lorraine Felt.

Members of the library staff pose in front of the circulation desk in 2013; from left to right are Jenna Weathers, Gail Nemetz, Erica Koestner, and Eileen Cashin.

Cutting a piece of the freshly
baked pie in the staff lounge
is Cindy Roach, joined by
library volunteer Fran Scott.

Alice Potts retired from the Osterville
Free Library in 1990 after having
been a librarian. The staff hosted
a luncheon in her honor, replete
with flowers, a gift, and balloons
proclaiming, "Happy Retirement!"

Seen in the staff lounge enjoying a cup of coffee are, from left to right, Connie Marr, Jean Haggerty, and Lorraine Felt. Ba and Barnes Riznik generously donated funds for the Employee Café at the new Osterville Free Library.

Staff members of the Osterville Village Library welcome all to Osterville, founded in 1639, with a village sign. From left to right are Gail Nemetz, Eileen Cashin, and Jenna Weathers.

## Seven

# THE NEW OSTERVILLE VILLAGE LIBRARY

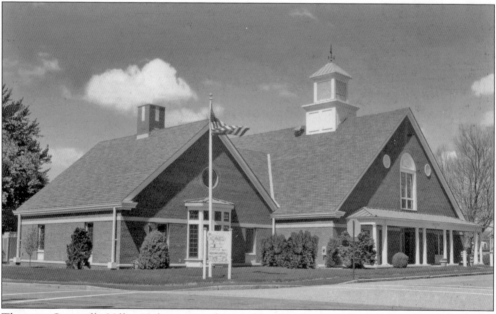

The new Osterville Village Library was designed by Charles T. Bellingrath and Jeremiah Ford and dedicated in 2012. The massive frontal gables, red brick, and white columns give the library a distinctly Colonial style, but it is truly a state-of-the-art library with three floors and a dedicated staff and supportive group of library patrons. The new library was opened on March 31, 2012, with a few hundred well-wishers in attendance. (Jeremiah Ford.)

Charles T. Bellingrath was the architect of the first phase of the proposed library, but died prior to its completion. A graduate of the Princeton University School of Architecture, he served as chairman of Russell Gibson von Dohlen in Connecticut and maintained a private practice for a decade in Osterville, where he designed various buildings at Cape Cod Academy, including Founders Hall. He also served as president of the New England Society of Architects.

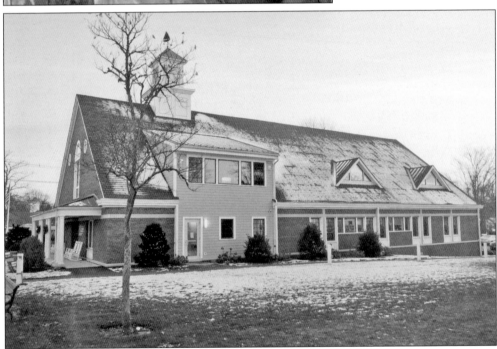

The Osterville Village Library, shown here in the winter of 2013, is not just an attractive building; the winter's early dusk radiates a warmth and an inviting aspect with a dusting of snow on the roof and lawn. A large, gilded open book was made by sign-maker Paul White and placed in the arch above the window in the facade gable.

Jeremiah Ford of Ford 3 Architects, LLC, a graduate of the Princeton University School of Architecture, was to adapt the plans of his former classmate Charles T. Bellingrath for the Osterville Village Library. Ford's attention to detail and skill as an architect made the final plan for the Osterville Village Library a welcoming and state-of-the-art design. As Ford said at the library dedication, "Think of a three-legged stool, well balanced and strong: One leg is the owner; one leg the builder and one leg the architect."

Robert Bownes stands at the podium welcoming trustees, staff, and the public to the ground breaking of the new Osterville Village Library. With library trustees both past and present, staff, patrons, and members of the public, it was a well-attended ceremony.

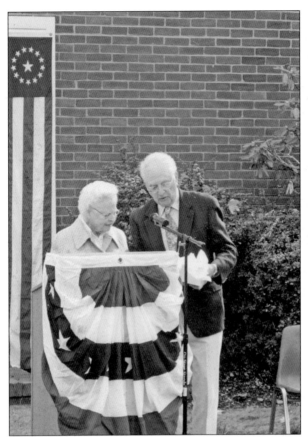

Standing at the bunting-draped podium at the ground-breaking ceremonies are Carolyn Crossett Rowland, library benefactor, and Robert Bownes, a library trustee and the cochairman of the capital campaign of the library.

On dedication day of the new Osterville Village Library, members of the Massachusetts State Police led the opening ceremonies with the flag of the United States and that of the state police held high as they parade to the front of the library where the dedication ceremonies were to be held.

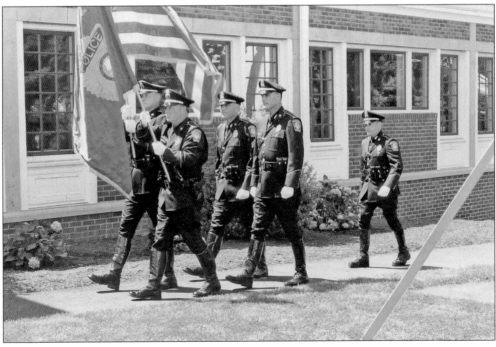

A smiling Elise Larner Hills was the winner of the lottery to be the first person to enter the new Osterville Village Library after its dedication.

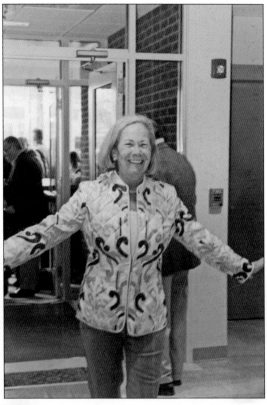

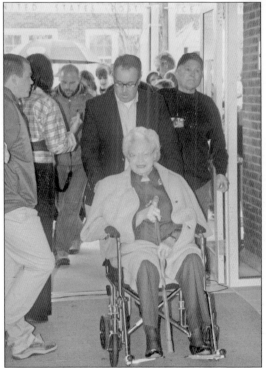

The second person to enter the newly dedicated library was Carolyn Crossett Rowland, whose support of the library over the years was both generous and an important legacy. Rowland said that the Osterville Village Library "belongs to everyone in the village of Osterville. It's yours to use and support."

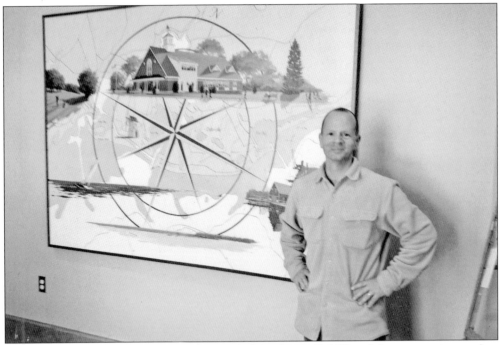

Lance Walker is the artist who created a mural of the Osterville Village Library, superimposed on a map of Cape Cod with a radiating compass, indicating that the library was the destination for all. Walker focuses on landscape and maritime subjects. Today, names of supporters of the library have been engraved on brass plates and placed on either side of the mural on the second floor.

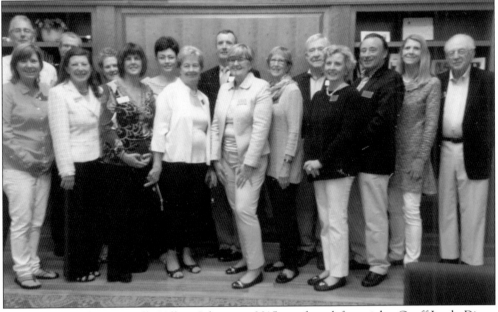

The trustees of the Osterville Village Library in 2015 are, from left to right, Geoff Lenk, Diane Pemberton, Mark Clifford, executive director Susan Belekewicz, Margaret McGowan, Cyndy Cotton, Talida Flores, Irene Haney, Sean Doherty, Laurie Young, Claudia Mahoney, Richard Coleman, Karen Bailey, Richard Sullivan, Sarah Hunter, and Robert Bownes.

The annual Osterville Chocolate Festival is in early February and draws chocoholics from around the Cape Cod area. Among events throughout the village, one of the more delicious is sampling the chocolate desserts submitted for competition. Cathryn Wright (right) serves samples to the judges in the distance who vote upon the most delicious, creative, and decadent of the desserts.

A smiling Geoff Lenk, a trustee of the library, serves coffee in the Rowland Reading Room during a holiday open house.

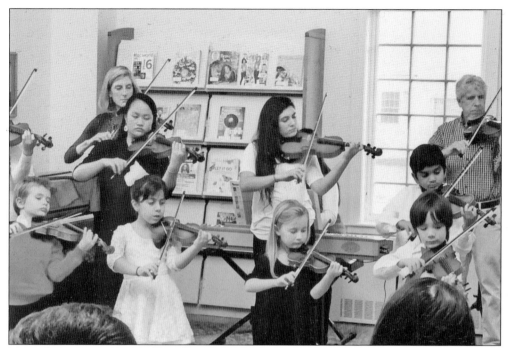

Musical events are often held in the Rowland Reading Room at the Osterville Village Library. Shown here, a group of adults and children from the Cape Conservatory serenades library patrons with a violin concert. The Cape Conservatory was founded in 1956, and today more than 1,200 students of all ages and skill levels participate in over 60 programs, as well as private and group vocal and instrumental instruction.

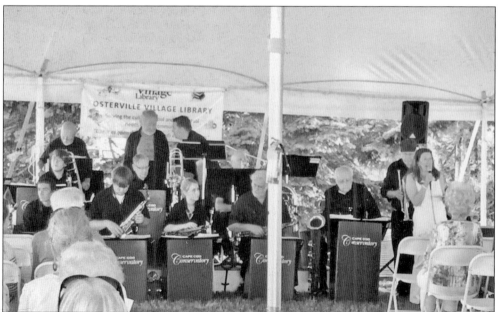

Susan T. Belekewicz introduces a concert by the Cape Conservatory that was one of the weekly performances that take place every summer on the library green, adjacent to the library. These free concerts are a wonderful way to spend an early evening in the village.

Sometimes, the library's summer concerts are so popular and the music so lively that children and adults get up to form an impromptu conga line that snakes around the seated patrons.

No event would be complete with a prepaid check-in table. Here, volunteers Haley Pemberton (left) and Neillie Fromhein welcome guests to the annual Mutts & Martinis event with wide smiles. This popular event encourages Osterville dogs to attend the chic cocktail party with their accompanying owners and is held under the tent on the library lawn.

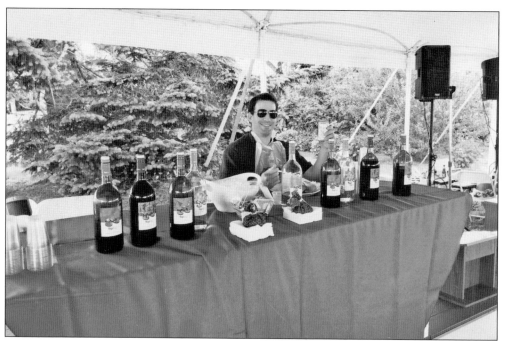

Often, library events held under the tent erected for the annual meeting in June are staffed by volunteers who serve libations. Here, Eric Merlesena, son of trustee Ellen Merlesena, ably mans the wine bar during the annual clambake.

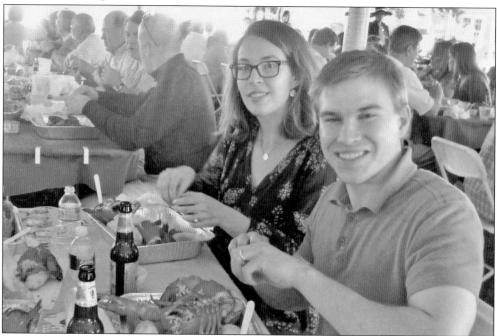

Enjoying the annual clambake under the tent are Megan and James Cote, proprietors of the Osterville House & Garden and members of the Emerging Leaders of the Osterville Village Library. The annual clambake is a wonderful way not only to spend a Sunday afternoon with family and friends but also to support the library while enjoying an old-fashioned Cape Cod dinner.

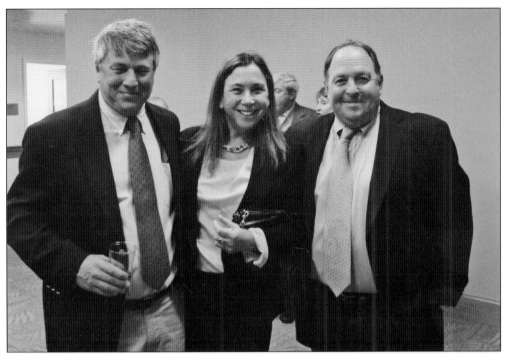

Seen at the Osterville Village Library opening reception are, from left to right, Peter Hansen, Nancy Kent, and E.J. Jaxtimer.

Pictured at the Osterville Village Library opening reception are Ralph and Susan Hansen.

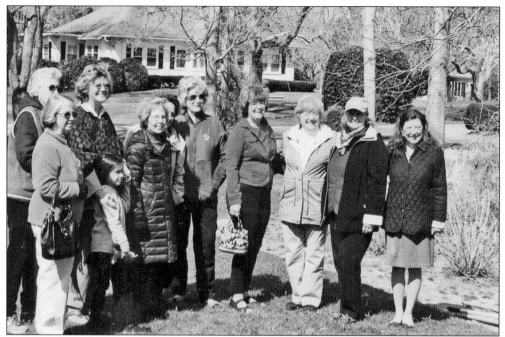

Members of the Osterville Garden Club gather on the lawn to celebrate Arbor Day in 2014 and their six decades of support and continued interest in the Osterville Village Library. Here, Linda Croteau, Irene Antkowiak, Hebe Manarelli, unidentified, Theresa Egan, Marlene Weir, Gail Reilly, Marion Nicastro, and Susan T. Belekewicz, the executive director of the library, welcome some of the club members.

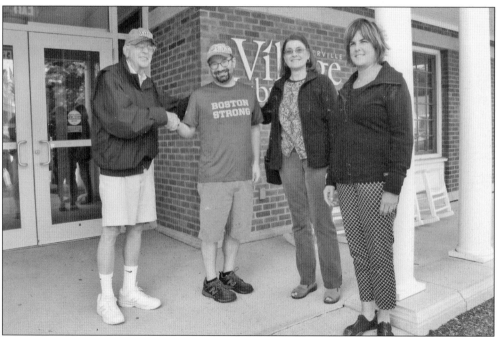

Standing at the entrance to the library are, from left to right, Robert Bownes, Jason Warren, Ellen Merlesena, and Cyndy Cotton.

Susan Belekewicz, peeking from a square in her Wanted sign, and Michelle Jacobson, both enthusiastic supporters of the Osterville Village Library, participated in the annual Village Day parade, using the signs for summer readers at the library. Their cowboy hats and red neckerchiefs add to the fun and ultimate reward of the benefits of summer reading. In 2013, there were over 100 young readers who read more than 500 hours.

Wally, the official Red Sox mascot, and Jack Cotton pose in front of the Osterville Village Library during Wally's visit in June 2012.

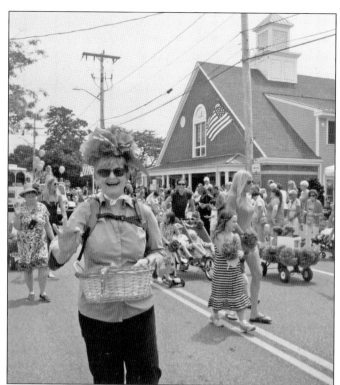

Laurie Young, president of the Osterville Village Library, marches down Wianno Avenue during Village Day, replete with a huge blue-flowered chapeau. The motif of the parade that year was "Osterville Hydrangeas," which was carried over to blue pom-poms as well as bedecking wagons.

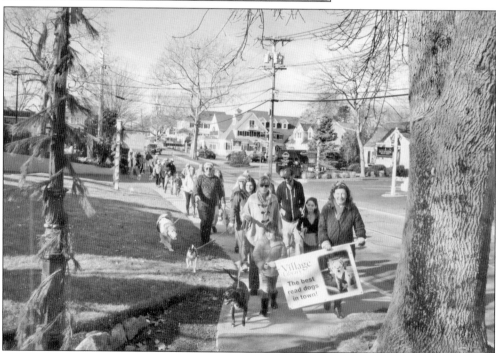

The Annual Osterville Library Dog Walk at the Holidays is a popular event as the canine residents of Osterville are said to be "the best-read dogs in town." Susan T. Belekewicz holds the banner as proud residents walk their dogs along Main Street in Osterville Village.

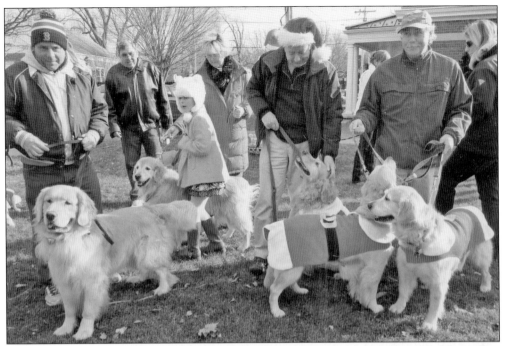

Sometimes, one realizes that the dog he or she has brought to the Annual Osterville Library Dog Walk is a very popular breed! Here, beautiful golden retrievers pose with their humans on the library lawn prior to the walk.

The Annual Osterville Library Road Race, often billed as a "Run for the Library," brings hundreds of runners who participate in the 5K race. Here, the huge gathering of runners awaits the start time, adding a sea of color and support in front of the Osterville Village Library.

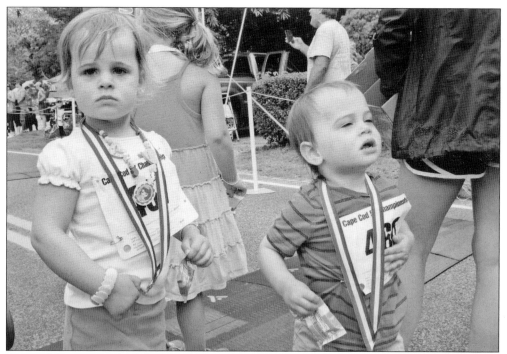

Some of the registered road-race runners are really quite young. Sophia Jansen and her brother Will Jansen sport their entry numbers as well as medals for the Cape Cod 5K Championship. There were special awards for those under 10 and over 70 as well as wheelchair participants.

Father and daughter runners, Nos. 492 and 493, are Lauren Lenk and her father, library trustee Geoff Lenk.

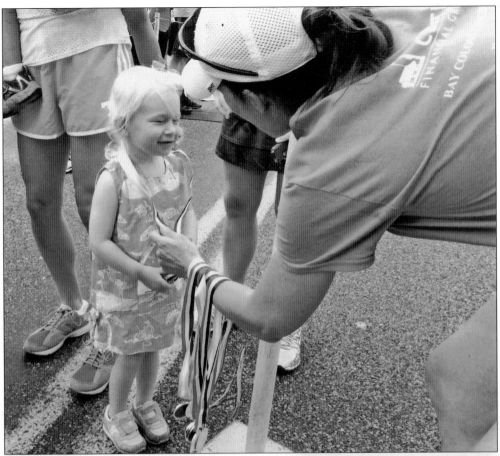

Kathleen Cartensen is awarded her medal for
participation in the Cape Cod 5K Championship.

Max Cotton, with his running medal suspended
from a colorful star-bedecked ribbon, is an
Emerging Leader of the Osterville Village Library.
The youth of Osterville Village will one day be
part of the library and its rich and ever-evolving
history and ensure its continued success.

Laurie Young, president of the trustees of the Osterville Village Library, helps to award medals strung on red, white, and blue ribbons at the end of the Osterville Village Road Race. On the left is library trustee Sean Doherty.

Amy Doherty and library trustee Sean Doherty handed out medals to those who completed the Cape Cod 5K Championship. Entries were limited to 400 runners who would complete the course for medals.

What could be better than winning a book at the Osterville Village Library? Helen Jacobson is held in father Russell Jacobson's arms as she holds aloft her prize, *The Cleaner Plate Club*—by esteemed food bloggers Beth Bader and Ali Benjamin—to mother Michelle Jacobson (left) and Susan T. Belekewicz, then executive director of the library.

Holding up Stripes, his stuffed animal, is Jack Cartensen. The annual Stuffed Animal Sleepover is an important event that brings child patrons to the library to hear a story in the Children's Room and then place their stuffed animals for their overnight stay at the library.

Sophie Jansen brought Roo, her stuffed kangaroo, to the Stuffed Animal Sleepover. These young library patrons enjoy the story hour by the children's librarian, but were quite adult by entrusting the library with their beloved stuffed animals for an overnight stay from home.

What is cooler than checking out books with your very own library card? The Lego projects on display were built by, from left to right, Dylan, Samson, and Tucker Cundiff; Samson and Tucker each holds his very own junior library card. The Lego club is held on the last Thursday of the month at 4:30 p.m.

A story hour in the Children's Room is not just enjoyable; the vividly colored carpeting, multicolored chairs and a comfortable window seat all make it a pleasant and welcoming place to be on a rainy day, which is a perfect day for a visit from Caz the therapy dog, seen lying in the center. He really seems to enjoy it when these young library patrons read to him.

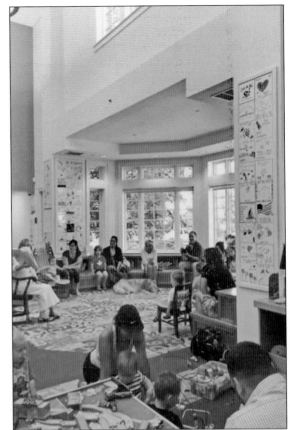

A storytelling hour can often bring a large number of children, along with their parents and grandparents, who create a circle of learning. Storytelling is an important way for children to not just listen to the spoken word, but to also visualize the story, thereby helping their development skills.

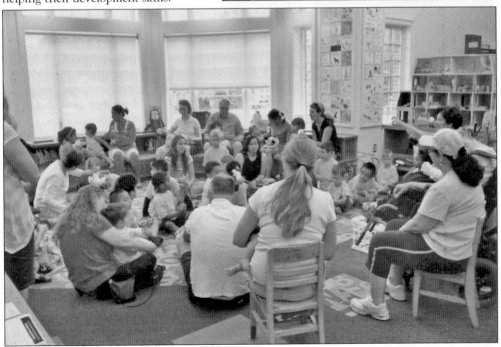

Congratulations to Lucille, the lucky winner of the Osterville Village Library's candy-corn guessing game from the Fall Festival in 2016, who holds her prize—a Mason jar chock-full of Indian candy corn.

Storytelling hours in the Children's Room at the library are always well attended. Obviously, from the intent looks of these young Ostervillians, the storytelling by the children's librarian is mesmerizing.

Sophie Jansen enjoys a front-row seat on the lap of Bev Cohan, listening to a story being read at the Children's Storytelling Hour at the Osterville Village Library. On the left are Laine Jansen and an unidentified friend kneeling behind them. Notice the ceramic tiles that were done by library patrons as a fundraiser for the new library, a wonderful and highly appropriate way to honor or memorialize a family, friend, or beloved pet.

Enjoying a children's story hour are Laine Jansen (left) and Sophie Jansen at the Osterville Village Library. The highly patterned carpeting, colorful walls, and welcoming space bring many to enjoy library activities.

Osterville Village Library Board of Trustees president Cyndy Cotton presents a gift to trustee Geoff Lenk at the library's annual meeting in 2015. Lenk is leaving the board after 20 years of service.

One of the successful events that the Friends of Osterville Village Library offer is the annual automobile raffle. Here, Ba Riznik (left) and Barbara Hanson sell tickets at the entrance to the library as a hopeful entrant writes a check. Often, the automobile offered is a luxury car that everyone has an equal chance of winning. As the library promotion notes, "Odds are better than megabucks and it supports the library!"

Christine Sellars Cotton is one of many talented vendors who offer handmade jewelry, attractive glass beads, and assorted custom arts and crafts to library supporters. Here, her wonderful art-glass wine stoppers, salad sets, and jewelry are indicative of the interesting items offered either on the green on certain Saturdays during the summer or indoors during inclement weather.

Sean Doherty awards a mini cake as a prize to Eric Steindel at the Wianno Golf Tournament. Begun in 1976 as the Osterville Free Library Classic Amateur Golf Classic, this annual event enticed contestants by advertising that their "participation in this gala event will be greatly appreciated by the Library and it should be a fun-day for all the contestants."

The registration table at the annual Wianno Golf Tournament in 2016 is staffed by, from left to right, Maryann Colombo, Claudia Mahoney, and Robert Bownes at the Wianno Golf Check-In overlooking the golf course. These golf tournaments were usually two-person best ball, using 75 percent of the player's handicap.

Volunteers at the annual Wianno Golf Tournament offered not just raffle tickets for assorted prizes such as gold clubs, a 50/50 raffle, and golf balls, but also awards for team scores, both gross and net. The wonderful Wianno Club Golf Course attracts many who play to support the library. From left to right are Maryann Colombo, Michelle Jacobson, Robert Bownes, Sue Golmanarick, and Sue Hansen.

Regina Silvia, dressed as Mrs. Claus, poses beside the festively decorated Christmas tree in the Rowland Reading Room. A dedicated volunteer who helps with lectures, children's storytelling, and the holiday open house, she holds a basket filled with all sorts of wonderful holiday things.

# ABOUT THE OSTERVILLE
# VILLAGE LIBRARY

Since its establishment in 1873 as the Osterville Literary Society, the librarians and executive directors of the Osterville Village Library have included the following:

Thankful Hamblin Ames
Rev. Edward Bourne Hinckley
Eliza R. Lovell
Bertha Lovell Hallett
Mary Crocker
Katherine E. Hinckley
Edith Nordling Wetherbee
Eva Watson Weber
Margaret A. Frazier
Margaret J. Kyle
Claudia Morner

Barbara Williams Baker
Cynthia Roach
Jeannie Van der Pyle
Koren Stembridge
Barbara Conathan
Patricia Jo Rogers
Lee Ann Amend
Susan Martin
Susan T. Belekewicz (executive director)
Cyndy Cotton (executive director)

# DISCOVER THOUSANDS OF LOCAL HISTORY BOOKS FEATURING MILLIONS OF VINTAGE IMAGES

Arcadia Publishing, the leading local history publisher in the United States, is committed to making history accessible and meaningful through publishing books that celebrate and preserve the heritage of America's people and places.

## Find more books like this at
## www.arcadiapublishing.com

Search for your hometown history, your old stomping grounds, and even your favorite sports team.

Consistent with our mission to preserve history on a local level, this book was printed in South Carolina on American-made paper and manufactured entirely in the United States. Products carrying the accredited Forest Stewardship Council (FSC) label are printed on 100 percent FSC-certified paper.

MADE IN THE USA